The **Professional** Guide to

photo
data

·····················

Richard Platt

The **Professional** Guide to

photo
data

Richard Platt

MITCHELL BEAZLEY

Edited and designed by
Mitchell Beazley Publishers
an imprint of Reed Consumer Books Limited
Michelin House
81 Fulham Road
London SW3 6RB, and Auckland,
Melbourne, Singapore, Toronto

Design: Stephen Bull Associates
Art Editor: Paul Burcher
Designer: Sue Corner
Editor: Jonathan Hilton
Production: Peter Phillips, Stewart Bowling

Copyright © 1989, 1991 and 1995
Reed International Books Limited
Text copyright © 1989, 1991 and 1995 Richard Platt
This edition fully revised and updated 1995

British Library Cataloguing in Publication Data

Platt, Richard 1953-
The professional guide to photo data
1. Photography. Technical aspects
I. Title
770'.28

ISBN 1-85732-692-X

Typeset by Dorchester Typesetting Group Ltd,
Dorchester, Dorset, England
Produced by Mandarin Offset
Printed and bound in China

Contents

Introduction

Photographers are not renowned for organisation. We keep information filed on scraps of paper or scribbled in the margins of half-forgotten books. Eventually most of us find ourselves in a frantic search for that one essential piece of information that will save the shot.

When it was first published in 1989 this book was an attempt to collect and collate all these vital facts between two covers. When the time came to update the book for a new edition, I had expected much to be obsolete. In fact, no changes of truly seismic scale have occurred, though there have been a few tremors. In particular, the much-predicted electronic imaging revolution signally failed to materialise. Non-silver cameras are still a rarity, except perhaps among news photographers and extremely well-heeled amateurs. What *has* changed most noticeably is the range of films available—up roughly 40%, allowing for double-counting of films that reach Europe under assumed names.

Digital technology has arguably had more impact in the darkroom. Even formerly complex tasks such as the restoration of faded images are now within the scope of any reasonably computer-literate photographer, though the necessary hardware can cost as much as a new car.

For this third edition I have also updated the digest of travel facts by sending out more than 200 new questionnaires. My thanks to the many individuals who collated and returned to me information about their countries. Here too, though, there has been surprisingly little change. C-41 processing has now become ubiquitous, with a minilab in even quite remote towns. But other facilities for photographers seem to be no better, and independent respondents still warn of unreliable slide processing.

Every book contains at least one error, and the first edition of this book was no exception. My thanks to the sharp-eyed readers who wrote in to point out my mistakes. I hope all of these have now been corrected, but if some have slipped through, please write care of the publisher.

Finally (and more concisely than in 1989) here are the criteria I used for including or excluding information: **Portability:** the book is a field guide. I've kept it small by excluding topics that could not be usefully covered in a few words. Because the emphasis is on location photography, there is only brief reference to processing. **Accessibility:** the information was sieved and systematically ordered so as to make it as easy to use as possible. **Formats:** the majority of pictures are now shot on 35mm. Although larger roll and sheet films are included, there is a bias towards the smaller format. **Novelty:** some of the information has traditionally been difficult to locate. In particular, the charts of the sun's position were specially calculated and drafted for this book.
Richard Platt 1995

Camera films

The list on the following pages includes virtually all general-purpose camera films available at the time of publication, and a few of the more commonly used special-purpose emulsions that might be of interest. With a few exceptions, workroom films are excluded, as are films that are sold only in sheets. Instant films are excluded because, by their very nature, if something goes wrong the problem is immediately obvious and steps can be taken to remedy the situation.

Make Many films do not carry their manufacturers' names—3M, in particular, makes a multitude of "own-label" brands for sale in stores ranging from supermarkets to chemist shops. These duplications are, therefore, excluded from the list.

Film Films listed are the professional version of each emulsion. An amateur packing is listed only where it differs in some respect, other than in aim point. For example, some amateur films are available in formats that differ from the professional version of the same film.

Speed Speeds listed are for normal processing in ideal conditions. For example, the speed of a daylight-balanced colour film is for 5500k daylight at shutter speeds between 1/10 and 1/1000. At speeds outside of this range, you might come up against reciprocity failure (see below).

Format This is only a guide to availability. Some films are available in a more limited range of sizes, or not at all in certain markets. The number found under "sheet film" identifies the notch shape in the chart on pages 20–21.

Reciprocity failure Exposure time in full seconds is followed by exposure correction in stops, using the camera's aperture control ring, then by filtration in Kodak CC values. For example, the entry for Fujichrome Sensia 200 reads "16=+1, 5M, $2^1/2$R; 64=+1, 5M, 5R". So when the meter indicates 16 seconds, you should open up the aperture by one stop, and use CC05 magenta and CC02.5 red filters. The figures that follow provide corrections for 64 seconds. Exposure correction always includes compensation for filter density. A blank indicates no data published. NR indicates not recommended, and exposures longer than those listed range will similarly produce "crossed curves"— a different colour cast in highlight and shadow areas. For most monochrome films, consult the table on page 72.

Edge numbers These are also listed on pages 15–19.

Processing Virtually all reversal films except Kodachrome are now process E6, and all negative films, process C-41. Exceptions are noted.

Daylight-balanced colour negative film (process C-41)

Make	Name	Code	ISO	Reciprocity Failure	135	120	70	Blk	Sht	135 Edge No	120 Edge No	Notes
3M	Scotch Color EXL 100		100	100 = +1, 20Y	•							Also as "own brand" film
3M	Scotch Color EXL 200		200	100 = +1, 20Y	•							Also as "own brand" film
3M	Scotch Color EXL 400		400	100 = +1, 20Y	•							Also as "own brand" film
Agfa	Agfacolor Ultra 50 Pro		50	1 = +1/2/10 = +2/100 = +3	•	•				Ultra 50 Pro	Ultra 50 Pro	
Agfa	Agfacolor HDC 100		100	10 = +1	•							
Agfa	Agfacolor XRG 100		100		•							
Agfa	Agfacolor Optima 125 Pro		125	1 = +1/10 = +2/100 = +3	•	•		•	42	Optima 125	Optima 125	
Agfa	Agfacolor Portrait 160 Pro		160	1 = +1/2/10 = +2/100 = +3	•	•				Portrait 160	Portrait 160	
Agfa	Agfacolor HDC 200		200	10 = +1	•							
Agfa	Agfacolor Optima 200 Pro		200	1 = +1/10 = +2/100 = +3	•	•				Optima 200	Optima 200	
Agfa	Agfacolor XRG 200		200		•							
Agfa	Agfacolor HDC 400		400	10 = +1	•							
Agfa	Agfacolor Optima 400 Pro		400	10 = +1/100 = +2	•	•				Optima 400	Optima 400	
Agfa	Agfacolor XRG 400		400		•							
Agfa	Agfacolor XRS 400 Pro		400	1 = +1/10 = +2/100 = +3	•	•		•		XRS 400	XRS 400	
Agfa	Agfacolor XRS 1000 Pro		1000	1 = +1/2	•	•				XRS 1000	XRS 1000	
Fuji	Fujicolor Reala	CS	100	4 = +1/2/16 = +1/64 = +2	•	•				REALA	REALA	
Fuji	Fujicolor Super G100	CN	100	4 = +1/2/16 = +1/64 = +2	•	•				G-100	G-100	
Fuji	Fujicolor 160 Pro S	NSP	160	4 = +1/2	•				05	160		
Fuji	Fujicolor NPS 160 Pro	NPS	160	2 = +1/2	•	•			39	NPS160	NPS160	
Fuji	Fujicolor Super G 200	CA	200	4 = +1/2/16 = +1/64 = +2	•					G-200		
Fuji	Fujicolor 400 Pro HG	NHG	400	4 = +1/2/16 = +1/1/2/64 = +2 1/2	•	•				NHG	NHG	
Fuji	Fujicolor Super G 400	CH	400	4 = +1/2/16 = +1 1/2/64 = +2 1/2	•	•				G-400	G-400	
Fuji	Fujicolor Super G 800 Pro	CZ	800	4 = +0 1/2/16 = +1 1/2/64 = +2 1/2	•					G-800		

Make	Name	Code	ISO	Reciprocity Failure	135	120	70	Blk	Sht	135 Edge No	120 Edge No	Notes
Fuji	Fujicolor Super G1600	CU	1600	$4 = +\frac{1}{2}/f16 = +1\frac{1}{2}/f64 = +2\frac{1}{2}$	●					1600		
Kodak	Ektar 25	CK	25	None to 10 secs	●					5100		Not USA
Kodak	Ektar 25 Pro	PHR	25	None to 10 secs		●				5327	6327	
Kodak	Royal Gold 25	RZ	25	None to 100	●					5100		USA only
Kodak	Ektapress Gold II 100 Pro	PJA	100	1 = +1, 20Y	●					5115		Not USA
Kodak	Ektapress Plus 100 Pro	PJA	100	None to 10 seconds	●					5115		USA only
Kodak	Ektar 100	CX	100	None to 10 secs	●					5226		Not USA
Kodak	Gold 100	GA	100	None to 10 sec	●					5095		USA only
Kodak	Gold II 100	GR	100	None to 10 sec	●					5211		Not USA
Kodak	Pro 100	PRN	100	None to 10 secs		●					6329	USA only
Kodak	Royal Gold 100	RA	100	None to 10 secs	●					5226		USA only
Kodak	Ektapress Gold II Multispeed Pro	PJM	100	Test for longer than 10 sec	●							May be push-processed to EI 1000
Kodak	Ektacolor 160 Pro	GPF	160	1 = +1, 20Y		●				5124	8124	USA only
Kodak	Ektacolor Pro Gold 160 Pro	GPX	160	None to 10 secs	●					5124		Not USA
Kodak	Vericolor III Pro, type S	VPS	160	NR	●	●	●		25	5026	6006	
Kodak	Ektapress Plus 200 Pro	PJZ	200	None to 10 sec	●					5116		USA only
Kodak	Gold 200	GB	200	None to 10 sec	●					5096		USA only
Kodak	Gold II 200	GS	200	None to 10 sec	●					5212		Not USA
Kodak	Royal Gold 200	RB	200	None to 10 sec	●					5081		USA only
Kodak	Ektacolor Pro Gold 400 Pro	GPY	400	No filter needed to 10 sec		●				5087	6087	Not USA
Kodak	Ektapress Gold II 400 Pro	PJB	400	None to 10 sec	●					5113		Not USA. May be push-processed
Kodak	Ektapress Plus 400 Pro	PJB	400	None to 10 sec	●					5113		USA only. May be push-processed
Kodak	Gold 400	GC	400	None to 10 sec	●					5097		USA only
Kodak	Gold II 400	GC	400	None to 10 sec	●					5097		Not USA
Kodak	Pro 400	PPF	400	None to 10 sec		●		●		5080	6080	USA only
Kodak	Pro 400 MC	PMC	400	None to 10 sec	●	●		●		5059	6059	USA only

Make	Name	Code	ISO	Reciprocity Failure	135	120	70	Blk	Sht	135 Edge No	120 Edge No	Notes
Kodak	Royal Gold 400	RC	400	None to 10 sec	•	•				5254		USA only
Kodak	Vericolor 400 Pro Type S	VPH	400	NR	•	•	•		59	5028	6028	Not USA
Kodak	Ektar 1000	CJ	1000	None to 10 sec	•	•				5110		Not USA
Kodak	Royal Gold 1000	RF	1000	None to 10 sec	•					5216		USA only
Kodak	Ektapress Gold II 1600 Pro	PJC	1600	NR	•					5030		Not USA. May be push-processed
Kodak	Ektapress Plus 1600 Pro	PJC	1600	NR	•					5030		USA only. May be push-processed
Konica	Color Impresa 50 Pro		50	10=+1/2		•						
Konica	Color Super XG100		100	10=+1	•			•				
Konica	Color SR-G 160 Pro		160	NR	•	•				SR-G 160		
Konica	Color Super XG200		200	10=+1	•							
Konica	Color Super XG400		400	10=+1	•			•				
Konica	Color SR-G3200		3200	10=+1/2/100=+1	•					SR-G 3200		
Polaroid	High Definition Color Print Film 100		100	10=+1	•					Color 100 HD2		
Polaroid	High Definition Color Print Film 200		200	10=+1	•					Color 200 HD2		
Polaroid	High Definition Color Print Film 400		400	10=+1, 10C	•					Color 400 HD2		
Tungsten-light balanced colour negative film (process C-41)												
Fuji	Fujicolor 160 Pro L	NLP	160	2=+1/2/8=+1/64=+1 1/2	•	•			18		NLP160	For exposures of 1/30 or longer
Fuji	Fujicolor NPL 160 Pro	NPL	160	4=+1/2;16=+1;32=+1	•	•			53		NPL160	
Kodak	Vericolor II Pro Type L	VPL	100	See instructions packed with film	•	•			45		6013	
Daylight-balanced colour reversal film (process E6 unless otherwise noted)												
3M	Scotch Chrome 100		100	1=+2/3,5Y/10=+1 1/2,10R/100=+2 1/2,15R	•							Also as "own brand" film
3M	Scotch Chrome 400		400	1=+1/2/10=+1,5Y/100=+2,10Y	•							Also as "own brand" film
3M	Scotch Chrome 800/3200 P		800	10=5Y at 800. Other speeds none to 100 secs	•							
3M	Scotch Chrome 1000		1000	10=±2/3,10B/100=+1 1/2,15M	•							Also as "own brand" film
Agfa	Agfachrome 50 RS Plus Pro		50	1=+1/2,5B/10=+1, 7.5B	•	•			16	RS 50 Plus	RS 50 Plus	

Make	Name	Code	ISO	Reciprocity Failure	135	120	70	Blk	Sht	135 Edge No	120 Edge No	Notes
Agfa	Agfachrome 100 RS Pro		100	1 = +1/2, 5B/10 = +1, 7.5B	•	•		•	38	RS 100 Plus	RS 100 Plus	
Agfa	Agfachrome CTx100		100	10 = +2/3, 5B	•					CTX 100		
Agfa	Agfachrome 200 RS Pro		200	1 = +1/2, 2.5Y/10 = +1, 7.5Y	•	•				200RS	200RS	
Agfa	Agfachrome 200 RS Pro		200	1 = +1/2, 2.5B/10 = +1, 5B	•	•				200RS	200RS	
Agfa	Agfachrome CT200		200	As for 200 RS	•					CT200		
Agfa	Agfachrome CTx200		200	10 = +1, 7.5Y	•					CTX 200		
Agfa	Agfachrome 1000 RS Pro		1000	1 = +1/3/10 = +2/3	•	•				1000 RS	1000 RS	
Fuji	Fujichrome 50	RF	50	4 = +1/3, 5M/16 = +2/3, 10M	•					RF		
Fuji	Fujichrome 50 Pro D	RFP	50	4 = +1/3, 5M/16 = +2/3, 10M	•			•	26	RFP		
Fuji	Fujichrome Velvia Pro	RVP	50	4 = +1/3, 5M/16 = +2/3, 10M	•	•		•	07	RVP	RVP	
Fuji	Fujichrome 100 pro D	RDP	100	4 = +1/3, 5M/16 = +2/3, 10M	•	•				RDP	RDP	
Fuji	Fujichrome Provia 100 Pro	RDPII	100	32 = +1/2/120 = +1, 2.5R	•	•		•	37	RDPII	RDPII	
Fuji	Fujichrome Sensia 100	RD	100	4 = +1/3, 5M/16 = +2/3, 10M	•			•	55	RD		
Fuji	Fujichrome Sensia 200	RM	200	16 = +1, 5M, 2.5R/64 = +1, 5M, 5R	•					RM		
Fuji	Fujichrome Provia 400 Pro	RHP	400	16 = +1, 5M, 2.5R/64 = +1, 5M, 5R	•	•				RHP	RHP	
Fuji	Fujichrome Sensia 400	RH	400	16 = +1, 5M, 2.5R/64 = +1, 5M, 5R	•					RH		
Fuji	Fujichrome Provia 1600 Pro	RSP	1600	4 = +1/2, 7.5R/16 = +2/3, 10M, 5R	•					RSP		
Kodak	Kodachrome 25	KM	25	1 = +1/2	•					5073		Process K14
Kodak	Kodachrome 25 Pro	PKM	25	1/10 = +1/3, 5R	•					5034		Process K14
Kodak	Ektachrome Elite 50	EA	50	1 = +1/2, 5M	•					5065		Not USA
Kodak	Ektachrome Panther 50 Pro	PRS	50	1 = +1/2, 5R	•	•				1066	2066	Not USA
Kodak	Ektachrome Panther 50X Pro	PRX	50	1 = +1/2, 5B	•	•				1067	2067	Not USA
Kodak	Ektachrome Underwater	UW	50	None to 1/10	•					5019		USA only
Kodak	Ektachrome 64 Pro	EPR	64	1 = +1/2, 5R	•	•		•	11	5017	6017	
Kodak	Ektachrome 64X Pro	EPX	64	1 = +1/2, 5R	•	•				5025	6025	

Make	Name	Code	ISO	Reciprocity Failure	135	120	70	Blk	Sht	135 Edge No	120 Edge No	Notes
Kodak	Kodachrome 64	KR	64	1/10 = +1/3, 5R	•					5032		Process K14
Kodak	Kodachrome 64 Pro	PKR	64	1/10 = +1/3, 5R	•	•				5033	6033	Process K14
Kodak	Ektachrome 100 Plus Pro	EPP	100	1 = +1/2, 5R	•	•		•	32	5005	6005	
Kodak	Ektachrome 100 Pro	EPN	100	1 = +1/2, 5R	•	•		•	48	5012,5058	6012,6058	
Kodak	Ektachrome 100X Pro	EPZ	100	1 = +1/2, 5R	•	•			43	5024	6024	
Kodak	Ektachrome Elite 100	EB	100	1 = +1/2, 5M	•					5045		Not USA
Kodak	Ektachrome Panther 100 Pro	PRP	100	1 = +1/2, 5B/10 = +1/2, 5B	•	•		•	36	1046	6046	Not USA
Kodak	Ektachrome Panther 100X Pro	PRZ	100	1 = +1/2, 5B/10 = +1/2, 5B	•	•		•		1048	6048	Not USA
Kodak	Lumiere 100 Pro	LPP	100	1 = +1/2, 5B/10 = +1/2, 5B	•	•			36	5046	6046	USA only
Kodak	Lumiere 100X Pro	LPZ	100	1 = +1/2, 5B/10 = +1/2, 5B	•	•				5048	6048	USA only
Kodak	Ektachrome 200 Pro	EPD	200	1 = +1/2, 5M	•	•		•	60	5036	6036	
Kodak	Ektachrome Elite 200	ED	200	1 = +1/3, 5R/10 = 1/2, 10R	•					5056		Not USA
Kodak	Ektachrome Panther 200X Pro	PRD	200	1 = +1/3, 5R/10 = +1/2, 10R	•	•						Not USA
Kodak	Kodachrome 200	KL	200	1 = +1/2, 10Y	•					5001		Process K14
Kodak	Kodachrome 200 Pro	PKL	200	NR	•					5002		Process K14
Kodak	Ektachrome 400X Pro	EPL	400	1 = +1/3, 5R.10 = +1/2, 10R	•	•				5075	6075	USA only
Kodak	Ektachrome Elite 400	EL	400	1 = +1/3, 5R/10 = 1/2, 10R	•					5074		Not USA
Kodak	Ektachrome Panther 400X Pro	EPL	400	1 = +1/3, 5R.10 = +1/2, 10R	•					5075	6075	Not USA
Kodak	Ektachrome P1600X Pro	EPH	1600	Test 1 to 100 sec	•					5040		USA only
Kodak	Ektachrome Panther P1600X Pro	EPH	1600	Test 1 to 100 sec	•					5040		Not USA
Konica	Chrome R-100		100	1 = +1/2, 5R	•					Konica Chrome 100		
Polaroid	High Definition Chrome		100	1 = +1/2, 5R	•					CS 100		
Tungsten-light-balanced colour reversal film (process E6 unless otherwise noted)												
3M	Scotch Chrome 640T		640	1 = +1/2/10 = +1/100 = +2, 10Y	•							Also as "own brand" film
Fuji	Fujichrome 64 Pro T	RTP	64	64 = +1/2, 2.5B	•	•	•	•	54	RTP	RTP	

Make	Name	Code	ISO	Reciprocity Failure	135	120	70	Blk	Sht	135 Edge No	120 Edge No	Notes
Kodak	Kodachrome 40 tungsten	KPA	40	$1 = +1/2, 5R$	•					5070		USA only. Balanced for 3400K. Process K14
Kodak	Ektachrome 64T Pro Tungsten	EPY	64	$100 = +1/3, 5R$	•	•			33	5018	6018	Optimized for long exposures
Kodak	Ektachrome 160 Pro Tungsten	EPT	160	$1 = +1/2, 5R$	•	•		•		5037	6037	
Kodak	Ektachrome 160 Tungsten	ET	160	$1 = +1/3, 10R$	•	•				5077		
Kodak	Ektachrome 320T Pro	EPJ	320	$1 = +1/3, 5R/10 = +1/2, 10R$	•			•		5042		
Black-and-white negative film												
Agfa	Agfapan APX 25 Pro		25	see mono table	•	•		•		Agfapan APX 25	Agfapan APX 25	
Agfa	Agfapan APX100 Pro		100	see mono table	•	•		•	13	Agfapan APX 100	Agfapan APX 100	
Agfa	Agfapan 400 Pro		400	see mono table	•	•		•	51	Agfapan 400	Agfapan 400	
Fuji	Neopan 400 Professional		400	see mono table	•			•		400PR		
Fuji	Neopan 1600 Professional		1600	see mono table	•					1600PR		
Ilford	Pan F		50	see mono table	•	•				Pan F	Pan F	
Ilford	100 Delta		100	see mono table	•	•		•		100 Delta	100 Delta	
Ilford	FP4 plus		125	see mono table	•	•		•	14	FP4 Plus	FP4 Plus	
Ilford	400 Delta Pro		400	see mono table	•	•		•	34	400 Delta	400 Delta	
Ilford	HP5 Plus		400	see mono table	•	•		•	35	HP5 Plus	HP5 Plus	
Ilford	XP2		400	see mono table	•	•		•	50	XP2	XP2	Dye image monochrome film—Process in C41 chemistry
Kodak	Technical Pan	TP	25	see mono table	•	•			-04	2415	6415	
Kodak	T-Max 100 Pro	TMX	100	$1 = +1/3/10 = +1/2/100 = +1$	•	•		•	10	5052	6052	
Kodak	Plus-X Pan	PX	125	see mono table	•			•		5062		
Kodak	Plus-X Pan Pro	PXP	125	see mono table			•		44		6057	
Kodak	Verichrome Pan	VP	125	see mono table		•					6041	USA only
Kodak	T-Max 400 Pro	TMY	400	$1 = +1/3/10 = +1/2/100 = +1 1/2$	•	•		•	40	5053	6053	

Make	Name	Code	ISO	Reciprocity Failure	135	120	70	Blk	Sht	135 Edge No	120 Edge No	Notes
Kodak	Tri-X Pan	TX	400	see mono table	●	●	●	●		5063	6043	
Kodak	Tri-X Pan Professional	TXP	400	see mono table		●	●		29		6049	code is for 220 film
Kodak	Recording film	RE	1000	see mono table	●					2475		Not USA
Kodak	T-Max P3200 Pro	TMZ	3200	$10 = +2/g\,f100 = +2$	●					5054		
Special films												
Agfa	Dia Direct		12		●					Dia Direct		Monochrome transparencies
Agfa	Agfaortho 25 Pro		25	$10 = +2/g\,f100 = +1.6$	●	●		●		Agfaortho 25	Agfaortho 25	Document film
Fuji	Fujichrome Duplicating film	CDU	n/a	n/a				●	17	CDU		
Fuji	Fujicolor Internegative film	IT-N	n/a	n/a				●	15	IT-N		
Kodak	Commercial Internegative	PLT	n/a	n/a				●	24	5325		
Kodak	Ektachrome Infrared	IE	n/a	$1/10 = +1.20B$	●					2236		Colour reversal film sensitive to IR. See page 96 for exposure. Requires E4 processing
Kodak	Ektachrome Slide Duplicating, Type K		n/a	n/a	●					8071		Not USA. For duplication of Kodachrome slides
Kodak	Fine Grain Release Positive	FRP	n/a	n/a				●		5302		Blue-sensitive mono film for slides from mono negs
Kodak	High-Speed Infrared	HIE	n/a	$100 = +2/3$	●				56	2481		Monochrome negative film sensitive to visible light and IR
Kodak	Vericolor slide film	VS	n/a	n/a	●					5072		For making slides from negatives
Konica	Infrared 750		n/a	n/a		●						Monochrome negative film sensitive to visible light and IR

Edge numbers

Many (but not all) 35mm and 120 films carry identifying marks along their edges, and this listing makes possible the identification of processed films using these marks. In addition to type marks, you may also see the film manufacturer's name. This has been omitted from the chart to save space.

Edge number	Make	Film name
120 films		
100 Delta	Ilford	100 Delta
200 RS	Agfa	Agfachrome 200 RS Pro
200RS	Agfa	Agfachrome 200 RS Pro
400 Delta	Ilford	400 Delta Pro
1000 RS	Agfa	Agfachrome 1000 RS Pro
2066	Kodak	Ektachrome Panther 50 Pro
2067	Kodak	Ektachrome Panther 50X Pro
6005	Kodak	Ektachrome 100 Plus Pro
6006	Kodak	Vericolor III Pro, type S
6013	Kodak	Vericolor II Pro Type L
6017	Kodak	Ektachrome 64 Pro
6018	Kodak	Ektachrome 64T Pro Tungsten
6024	Kodak	Ektachrome 100X Pro
6025	Kodak	Ektachrome 64X Pro
6028	Kodak	Vericolor 400 Pro Type S
6033	Kodak	Kodachrome 64 Pro
6036	Kodak	Ektachrome 200 Pro
6037	Kodak	Ektachrome 160 Pro Tungsten
6041	Kodak	Verichrome Pan
6043	Kodak	Tri-X Pan
6046	Kodak	Ektachrome Panther 100 Pro
6046	Kodak	Lumiere 100 Pro
6048	Kodak	Ektachrome Panther 100X Pro
6048	Kodak	Lumiere 100X Pro
6049	Kodak	Tri-X Pan Professional
6052	Kodak	T-Max 100 Pro
6053	Kodak	T-Max 400 Pro
6057	Kodak	Plus-X Pan Pro
6058	Kodak	Ektachrome 100 Pro
6059	Kodak	Pro 400 MC
6075	Kodak	Ektachrome 400X Pro
6075	Kodak	Ektachrome Panther 400X Pro
6080	Kodak	Pro 400
6087	Kodak	Ektacolor Gold II 400 Pro
6327	Kodak	Ektar 25 Pro

Edge number	Make	Film name
120 films cont.		
6329	Kodak	Pro 100
6329	Kodak	Vericolor HC Pro
6415	Kodak	Technical Pan
8124	Kodak	Ektacolor Gold II 160 Pro
Agfaortho 25	Agfa	Agfaortho 25 Pro
Agfapan 400	Agfa	Agfapan 400 Pro
Agfapan APX 100	Agfa	Agfapan APX100 Pro
Agfapan APX 25	Agfa	Agfapan APX 25 Pro
FP4 Plus	Ilford	FP4 plus
G-100	Fuji	Fujicolor Super G100
G-400	Fuji	Fujicolor Super G 400
HP5 Plus	Ilford	HP5 Plus
NHG	Fuji	Fujicolor 400 Pro HG
NLP160	Fuji	Fujicolor 160 Pro L
NPL160	Fuji	Fujicolor NPL 160 Pro
NPS160	Fuji	Fujicolor NPS 160 Pro
NSP160	Fuji	Fujicolor 160 Pro S
Optima 125	Agfa	Agfacolor Optima 125 Pro
Optima 200	Agfa	Agfacolor Optima 200 Pro
Optima 400	Agfa	Agfacolor Optima 400 Pro
Pan F	Ilford	Pan F
Portrait 160	Agfa	Agfacolor Portrait 160 Pro
RDP	Fuji	Fujichrome 100 pro D
RDPII	Fuji	Fujichrome Provia 100 Pro
REALA	Fuji	Fujicolor Reala
RFP	Fuji	Fujichrome 50 Pro D
RHP	Fuji	Fujichrome Provia 400 Pro
RS 100 Plus	Agfa	Agfachrome 100 RS Pro
RS 50 Plus	Agfa	Agfachrome 50 RS Plus Pro
RTP	Fuji	Fujichrome 64 Pro T
RVP	Fuji	Fujichrome Velvia Pro
Ultra 50 Pro	Agfa	Agfacolor Ultra 50 Pro
XP2	Ilford	XP2
XRS 1000	Agfa	Agfacolor XRS 1000 Pro
XRS 400	Agfa	Agfacolor XRS 400 Pro
35mm films		
100 Delta	Ilford	100 Delta
160	Fuji	Fujicolor 160 Pro S
200 RS	Agfa	Agfachrome 200 RS Pro
200RS	Agfa	Agfachrome 200 RS Pro
400 Delta	Ilford	400 Delta Pro
400PR	Fuji	Neopan 400 Professional

Edge number	Make	Film name
35mm films cont.		
1000 RS	Agfa	Agfachrome 1000 RS Pro
1046	Kodak	Ektachrome Panther 100 Pro
1048	Kodak	Ektachrome Panther 100X Pro
1066	Kodak	Ektachrome Panther 50 Pro
1067	Kodak	Ektachrome Panther 50X Pro
1600	Fuji	Fujicolor Super G1600
1600PR	Fuji	Neopan 1600 Professional
2236	Kodak	Ektachrome Infrared
2415	Kodak	Technical Pan
2475	Kodak	Recording film
2481	Kodak	High-Speed Infrared
5001	Kodak	Kodachrome 200
5002	Kodak	Kodachrome 200 Pro
5005	Kodak	Ektachrome 100 Plus Pro
5017	Kodak	Ektachrome 64 Pro
5018	Kodak	Ektachrome 64T Pro Tungsten
5019	Kodak	Ektachrome Underwater
5024	Kodak	Ektachrome 100X Pro
5025	Kodak	Ektachrome 64X Pro
5026	Kodak	Vericolor III Pro, type S
5028	Kodak	Vericolor 400 Pro Type S
5030	Kodak	Ektapress Gold II 1600 Pro
5030	Kodak	Ektapress Plus 1600 Pro
5032	Kodak	Kodachrome 64
5033	Kodak	Kodachrome 64 Pro
5034	Kodak	Kodachrome 25 Pro
5036	Kodak	Ektachrome 200 Pro
5037	Kodak	Ektachrome 160 Pro Tungsten
5040	Kodak	Ektachrome P1600X Pro
5040	Kodak	Ektachrome Panther P1600X Pro
5042	Kodak	Ektachrome 320T Pro
5045	Kodak	Ektachrome Elite 100
5046	Kodak	Lumiere 100 Pro
5048	Kodak	Lumiere 100X Pro
5052	Kodak	T-Max 100 Pro
5053	Kodak	T-Max 400 Pro
5054	Kodak	T-Max P3200 Pro
5056	Kodak	Ektachrome Elite 200
5058	Kodak	Ektachrome 100 Pro
5059	Kodak	Pro 400 MC
5062	Kodak	Plus-X Pan
5063	Kodak	Tri-X Pan

Edge number	Make	Film name
35mm films cont.		
5065	Kodak	Ektachrome Elite 50
5070	Kodak	Kodachrome 40 tungsten
5071	Kodak	Ektachrome Slide Duplicating
5072	Kodak	Vericolor slide film
5073	Kodak	Kodachrome 25
5074	Kodak	Ektachrome Elite 400
5075	Kodak	Ektachrome 400X Pro
5075	Kodak	Ektachrome Panther 400X Pro
5077	Kodak	Ektachrome 160 Tungsten
5080	Kodak	Pro 400
5081	Kodak	Royal Gold 200
5087	Kodak	Ektacolor Gold II 400 Pro
5095	Kodak	Gold 100
5096	Kodak	Gold 200
5097	Kodak	Gold 400
5097	Kodak	Gold II 400
5100	Kodak	Ektar 25
5100	Kodak	Royal Gold 25
5110	Kodak	Ektar 1000
5113	Kodak	Ektapress Gold II 400 Pro
5113	Kodak	Ektapress Plus 400 Pro
5115	Kodak	Ektapress Gold II 100 Pro
5115	Kodak	Ektapress Plus 100 Pro
5116	Kodak	Ektapress Plus 200 Pro
5124	Kodak	Ektacolor 160 Pro
5124	Kodak	Ektacolor Gold II 160 Pro
5211	Kodak	Gold II 100
5212	Kodak	Gold II 200
5216	Kodak	Royal Gold 1000
5226	Kodak	Ektar 100
5226	Kodak	Royal Gold 100
5254	Kodak	Royal Gold 400
5302	Kodak	Fine Grain Release Positive
5325	Kodak	Commercial Internegative
5327	Kodak	Ektar 25 Pro
8071	Kodak	Ektachrome Slide Duplicating. Type K
Agfaortho 25	Agfa	Agfaortho 25 Pro
Agfapan APX 100	Agfa	Agfapan APX 100 Pro
Agfapan APX 25	Agfa	Agfapan APX 25 Pro
Agfapan 400	Agfa	Agfapan 400 Pro
CDU	Fuji	Fujichrome Duplicating film
Color 100 HD2	Polaroid	High Definition Color Print Film 100

Edge number	Make	Film name
35mm films cont.		
Color 200 HD2	Polaroid	High Definition Color Print Film 200
Color 400 HD2	Polaroid	High Definition Color Print Film 400
CS 100	Polaroid	High Definition Chrome
CT200	Agfa	Agfachrome CT200
CTX 100	Agfa	Agfachrome CTx100
CTX 200	Agfa	Agfachrome CTx200
Dia Direct	Agfa	Dia Direct
FP4 Plus	Ilford	FP4 plus
G-100	Fuji	Fujicolor Super G100
G-200	Fuji	Fujicolor Super G 200
G-400	Fuji	Fujicolor Super G 400
G-800	Fuji	Fujicolor Super G 800 Pro
HP5 Plus	Ilford	HP5 Plus
IT-N	Fuji	Fujicolor Internegative film
Konica Chrome 100	Konica	Chrome R-100
NHG	Fuji	Fujicolor 400 Pro HG
NPS160	Fuji	Fujicolor NPS 160 Pro
Optima 125	Agfa	Agfacolor Optima 125 Pro
Optima 200	Agfa	Agfacolor Optima 200 Pro
Optima 400	Agfa	Agfacolor Optima 400 Pro
Pan F	Ilford	Pan F
Portrait 160	Agfa	Agfacolor Portrait 160 Pro
RD	Fuji	Fujichrome Sensia 100
RDP	Fuji	Fujichrome 100 pro D
RDPII	Fuji	Fujichrome Provia 100 Pro
REALA	Fuji	Fujicolor Reala
RF	Fuji	Fujichrome 50
RFP	Fuji	Fujichrome 50 Pro D
RH	Fuji	Fujichrome Sensia 400
RHP	Fuji	Fujichrome Provia 400 Pro
RM	Fuji	Fujichrome Sensia 200
RS 100 Plus	Agfa	Agfachrome 100 RS Pro
RS 50 Plus	Agfa	Agfachrome 50 RS Plus Pro
RSP	Fuji	Fujichrome Provia 1600 Pro
RTP	Fuji	Fujichrome 64 Pro T
RVP	Fuji	Fujichrome Velvia Pro
SO-366	Kodak	Ektachrome Duplicating SE
SR-G 160	Konica	Color SR-G 160 Pro
SR-G 3200	Konica	Color SR-G3200
Ultra 50 Pro	Agfa	Agfacolor Ultra 50 Pro
XP2	Ilford	XP2
XRS 1000	Agfa	Agfacolor XRS 1000 Pro
XRS 400	Agfa	Agfacolor XRS 400 Pro

Notch codes

This compilation of sheet film types starts with single-notch films, then two notches, and so on. Having counted the notches, feel the shape of the notch closest to the long side of the film, then work inward. In the list, the sharpest "V" notch appears first and the bluntest "crescent" last. For reasons of space, the characteristics of some of the films in this list do not appear in the preceding chart.

None and One Notch

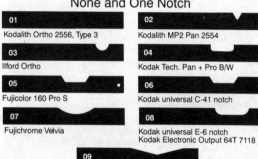

01 Kodalith Ortho 2556, Type 3

02 Kodalith MP2 Pan 2554

03 Ilford Ortho

04 Kodak Tech. Pan + Pro B/W

05 Fujicolor 160 Pro S

06 Kodak universal C-41 notch

07 Fujichrome Velvia

08 Kodak universal E-6 notch
Kodak Electronic Output 64T 7118

09 Kodak universal C-41 notch

Two Notches

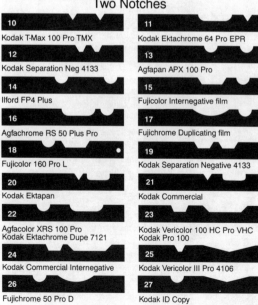

10 Kodak T-Max 100 Pro TMX

11 Kodak Ektachrome 64 Pro EPR

12 Kodak Separation Neg 4133

13 Agfapan APX 100 Pro

14 Ilford FP4 Plus

15 Fujicolor Internegative film

16 Agfachrome RS 50 Plus Pro

17 Fujichrome Duplicating film

18 Fujicolor 160 Pro L

19 Kodak Separation Negative 4133

20 Kodak Ektapan

21 Kodak Commercial

22 Agfacolor XRS 100 Pro
Kodak Ektachrome Dupe 7121

23 Kodak Vericolor 100 HC Pro VHC
Kodak Pro 100

24 Kodak Commercial Internegative

25 Kodak Vericolor III Pro 4106

26 Fujichrome 50 Pro D

27 Kodak ID Copy

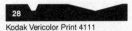

28
Kodak Vericolor Print 4111

Three notches

29
Kodak Tri-X Pan Pro TXP

30
Kodak Pan Matrix 4149

31
Kodak Pan Masking 4570

32
Kodak Ektachrome 100 Plus Pro EPP

33
Kodak Ektachrome 64T Pro EPY

34
Ilford 400 Delta Pro

35
Ilford HP5 Plus

36
Kodak Ektachrome Panther 100 PRP
Kodak Ektachrome Lumiere 100 LPP

37
Fujichrome 100 Pro D

38
Agfachrome RS 100 Plus

39
Fujicolor NPS 160 Pro

40
Kodak T-Max 400 Pro TMY

41
Kodak Contrast Process Ortho

42
Agfacolor Optima 125

43
Kodak Ektachrome 100X Pro EPZ

44
Kodak Plus-X Pan Pro PXP

45
Kodak Vericolor II Pro Type L VPL

46
Kodak Vericolor Interneg 4112

Four and Five Notches

47
Kodak Ektachrome Dupe ESD

48
Kodak Ektachrome 100 Pro EPN

49
Kodak *New* Ektachrome 100 Pro EPN

50
Ilford XP2

51
Agfapan 400 Pro

52
Kodak Electronic Output 100 7122

53
Fujicolor NPL 160 Pro

54
Fujichrome 64 Pro T

55
Fujichrome Provia 100 Pro

56
Kodak High Speed Infrared

57
Kodak Tri-X Ortho 4163

58
Kodak Pro Copy 4125

59
Kodak Vericolor 400 Pro VPH

60
Kodak Ektachrome 200 Pro EPD

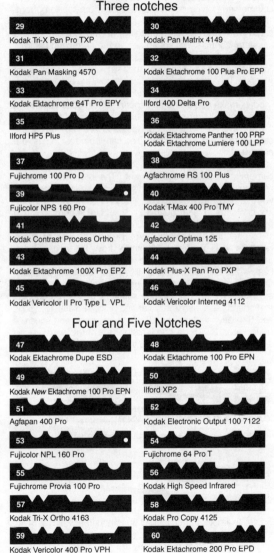

DX codes

The "DX" pattern of squares on a 35mm cassette was introduced to program the film speed automatically into the camera, and has now been almost universally adopted. The pattern of conductive and insulating squares forms two columns stretching down the cassette from top to bottom. The squares are in three basic groups: the left-hand column (seen with the spool protruding at the bottom of the cassette) controls film speed set; in the right-hand column, the second, third and fourth squares specify film length, and the bottom two describe the film type—negative or reversal. The top two squares in each row are always silver.

Few current cameras use all squares, but most newer models make use of the film speed setting squares, and on some cameras there is no manual adjustment of film speed: if your films are over- or underexposed you can't adjust the camera to make a correction. You can, however, adjust the cassette.

Before trying this, though, check the contacts in the camera's cassette compartment. The simplest cameras read only squares 2 and 4, and distinguish between films with speeds of ISO 100, 200, 400 and 800. Cameras with five contacts, to read squares 2–6, set film speeds to within $\frac{1}{3}$ stop between ISO 25 and 5000.

To alter the ISO value programmed into one of these cameras, it is necessary to know how the code works. Squares 2, 3 and 4 set the film speed on a doubling basis—25, 50, 100, 200 and so on. Squares 5 and 6 fine-tune exposure by $\frac{1}{3}$-stop intervals. When 2, 3 and 4 are all black, ISO 25 is set. When square 2 is silver, it doubles film speed: so when 2 is silver and 3 and 4 black, ISO 50 is set. Similarly, square 3 quadruples film speed and square 4 multiplies it by 16. In combination, the three squares can specify film speed from ISO 25 to 3200, as shown here:

Film Speed	25	50	100	200	400	800	1600	3200
Square 2	■		■		■		■	
Square 3	■	■			■	■		
Square 4	■	■	■	■				

To fine-tune exposure use the other two squares:

	$+\frac{2}{3}$	$+\frac{1}{3}$	$+0$
Square 5		■	
Square 6			■

So, for example, to rate an ISO 50 transparency film at EI 64, stick a piece of insulation tape over square 6 and make square 5 conductive, perhaps by using a square of metal foil.

Batch-testing film

Practical tests enable you to predict how film will perform under real conditions or to compare similar films. Tests should reflect how you work—if you take mainly landscapes, don't test the film using studio flash. This, indeed, is an argument in favour of assessing film yourself rather than relying on published reports.

The following subjects test most of the important characteristics of today's colour films:

Grey scale This need not be a printed scale, but it should include an 18 percent grey card as a reference tone. Crumpled black fabric provides a good test of shadow detail. Any brilliant white object tests highlight detail and reveals grain structure—flowers are a good choice.

Primary colours Brilliant hues tax the abilities of a film to the extreme, and arguably provide the most noticeable differences between various emulsions. Brightly coloured, yet detailed, subjects, such as clothing, are a better choice than uniform tones, since some films sacrifice detail when colours (especially red) are highly saturated.

Flesh tones Most film manufacturers aim to create neutral or slightly warm skin tones, but achieving this objective may mean sacrificing neutrality of highlights or shadows. So in evaluating transparencies, take care to compare the hues of skin tones with dark and light areas.

Fine detail If possible, incorporate fine detail in all areas of the tonal scale in order to check sharpness in both highlights and shadows. Fur or hair makes a good subject.

White fabric Many white fabrics fluoresce in ultraviolet light, and though the human eye has little sensitivity to the blue colour this creates, some films exaggerate it. White fabric tests for this problem.

Blue flowers At the other end of the spectrum, many blue flowers and some green synthetic fibres reflect strongly in the near infrared. Again, the eye is insensitive to these wavelengths, but some films do pick them up, turning blue flowers mauve. Corrective filtration is almost impossible, so testing for this characteristic is of fundamental importance in some specialist fields. To check if a subject reflects very deep red, view it through a deep red Wratten 70 filter using tungsten light, and make a comparison with a subject of similar colour that is known to reproduce well on film.

Consistency Take care to match illuminant colour to the film's sensitivity, or use filtration to correct any imbalance. Shoot films to be compared in the same camera and bracket pictures over a wide range at ⅓-stop intervals to check true speed. Most of all, be sure to use photographic techniques that reflect your normal practice: don't, for example, use an incident light meter if you normally rely on the meter built in to the camera.

Film storage before processing

The useful life of film depends not only on how you store it but also on how critical you are. "Professional" emulsions are manufactured for critical use and are supplied in optimum condition. To maintain this peak of "ripeness", these films must be stored with great care. Films manufactured for amateurs are despatched in "unripe" form and need less-careful storage.

Temperature For long-term storage keep all types of colour film refrigerated—at 10°C (50°F) or colder; professional emulsions should be kept at a low temperature even in the short term. High temperatures will damage any film, including monochrome emulsions, so avoid sources of heat, such as a flash power pack that may warm up in use or the rear window shelf in a car.

Freezing film slows changes in the emulsion and may be worthwhile for extended storage. However, bear in mind that freezing does not slow all sources of change, as explained below. Freezers for storing film should be kept in the range 0° to –10°C (–18° to –23°F).

Frozen and refrigerated film needs time to warm to room temperature before the package is opened. Take the film from its outer packing, separate the cartons and stand them on their smallest side, then leave them at room temperature for the times indicated below. Don't hurry the procedure by using heat sources such as a hair dryer.

Warm-up times (hrs/min)

Packing	Temp rise 14°C (57°F)	56°C (132°F)
35mm cassettes	1	1.30
Roll film	0.30	1
25 sheets (any size)	1	1.30
50 sheets	2	3
35mm bulk can	3	5
70mm, 100ft	3	5

Ionizing radiation The most familiar source of ionizing radiation is the airport X-ray machine (see page 113 for precautions), but the natural environment everywhere emits some background radiation that can in time harm film. The effect is worth considering only with ultra-high-speed films and long-term storage: with these films the value of freezing (as opposed to refrigeration) is debatable.

Humidity Damp conditions damage film, and though film

packaging inhibits moisture penetration, only foil wraps are hermetically sealed. Ideally, store film in low-humidity conditions—below 60 percent relative humidity. You can measure humidity using a variety of methods, but common sense also provides important clues—if labels start to curl up, for example, then the humidity is too high.

If your chosen storage place is naturally humid (refrigerators and freezers are), protect film in an airtight container, such as a polythene bag or a screw-topped jar. Note, however, that adhesive tape does not form a watertight seal, so cans sealed with tape are suitable only for the short-term storage of film.

Chemical hazards Many everyday items give off gases that harm films. Solvents and mothballs are particular hazards, but mercury vapour from broken thermometers and exhaust fumes from motor vehicles are perhaps less obvious culprits. All these compounds damage film and they may be given off in small quantities by cleaning compounds, paints and adhesives: even some camera bags emit formaldehyde. Store film away from obvious sources of these hazards, in airtight containers where possible.

Hazardous substances

- Ammonia
- Paints
- Solvents
- Cleaners
- Adhesives
- Chipboard
- Sulphides
- Glue
- Mothballs
- Motor vehicle exhausts
- Permanent-press trousers (!)
- Stain-resistant fabric finishes
- Mildew preventatives
- Insecticides
- Foam in place insulation
- Industrial pollution
- Particle board
- Cavity-wall insulation

Physical factors These hazards are so obvious that they are frequently overlooked. A household catastrophe, such as a leaking pipe, can be doubly damaging if the deluge engulfs 100 rolls of film stored at floor level. Simple precautions are all that's needed to prevent film being crushed, burned, soaked, fumigated, eaten by rats or rendered useless in some other way.

After exposure Whenever possible, film should be processed immediately after exposure. If processing is delayed, follow the same storage guidelines as for unexposed film. Where processing services are unreliable, it may seem more sensible to post film to a distant location for processing. However, this requires careful consideration, because mailbags may sit for hours in a locked van on the hot airport tarmac. In preference, post film at a main sorting office, or if the mail is not reliable, take postage-paid packages to the airport and pass them to passengers on homeward-bound flights.

Storing images

On the touchy topic of the stability of colour pictures, most film manufacturers cover themselves by stating on the packaging "all dyes fade with time". This is true but not particularly helpful. In fact the truth is that some films fade faster than others and there are steps you can take to minimize fading.

In general terms, the advice on the previous pages regarding the storage of unprocessed film applies equally to processed transparencies and negatives (print stability is too broad a topic to be considered here). However, post-processing storage brings film into contact with a greater diversity of potentially dangerous substances, so there are other factors to consider.

Film choice Different films fade at different rates, and photographers who maintain large stock libraries of colour pictures have for decades favoured Kodachrome for its longevity. In recent years, the permanence of other transparency films has improved significantly, and the gap between Kodachrome and substantive emulsions is no longer as great. Colour films will never match monochrome for permanence, though: processed and stored properly, silver-image black and white films have a lifespan measured in centuries. Current Kodachrome transparencies should last a century in dark storage, and E6 films 50 years. Colour negative films (and dye-image black and white films such as XP1) have the worst record and, even in ideal conditions, fading will start within a decade. In a slide projector, the situation is a little different: Kodachrome transparencies actually fade faster than E6 films, so for continuous projection, as in an AV installation, use E6 films.

Storage conditions Unsuitable storage greatly accelerates fading. Negatives should ideally be stored in acid-free paper sleeves in metal cabinets. Transparencies will last longer if air can circulate around the image, so avoid glass mounts where possible. The biggest threat to a slide is PVC, because it contains plasticizers that can cause rapid deterioration. Never use plastic storage and display sheets containing PVC.

Handling Dye loss in colour films needs to be seen in perspective: the risk is probably insignificant when compared with the damage done to photographs by constant handling. Thus the most important step you can take to preserve images is to restrict access. Persuade clients to select images using prints or duplicates and circulate only dupes of important images for reproduction.

Where permanence is vital, and constant access is not necessary, images are best preserved in cold storage. For this purpose, Kodak sells storage envelopes for processed film that can be hermetically sealed with a domestic iron, but film must first be conditioned to 25–30 percent relative

humidity. This is an elaborate procedure and running a freezer full of transparencies involves an ongoing and an unwelcome expense. However, for popular stock pictures that are repeatedly re-used, the trouble and expense are probably justified.

Restoring faded images

The most straightforward way to restore colour to a faded original is to make a simple duplicate and use colour filtration to correct the selective loss of dye. Loss of overall contrast can also be reversed in a rough-and-ready way by duplicating onto ordinary camera film, rather than special duplicating film, which has an inherently lower contrast. Manual retouching onto an enlarged transparency is a lengthy and expensive procedure but it goes some way toward putting back colour—albeit selectively.

Electronic methods

Unfortunately, fading of photographic images takes place at different rates in different areas of the emulsion. In dark storage, fading is generally proportional to original density, so that there is not a consistent loss of colour. Instead, shadows fade faster than highlights, and the result is a loss of contrast in one or more layers.

Faded transparencies can be restored only by increasing colour contrast selectively. This is possible if the transparency is printed using colour separation techniques. There are "wet" methods of doing this, but computer manipulation offers a much more straightforward approach. The first step is to have the transparency scanned to produce an file that a computer can read and change.

In principle the process is relatively quick and simple: using retouching software such as Adobe Photoshop, you can adjust the colour balance of the image overall, or change the saturation of each "dye layer" individually, and monitor the effect on screen. While you're about it you can even sharpen parts or the whole of the picture, and effortlessly remove that film carton you dropped in the foreground. Once the image is as you want it, you save it to disc, and take the disc to a bureau to be output to film.

In practice, this may not be an operation you can carry out at home. Even a 35mm transparency scanned at high resolution requires huge amounts of memory and disc space. Larger formats require proportionately more. For all but the smallest images, restoring colour to a faded transparency is a task for a professional bureau. The good news is that the process is almost routine, and you are likely to recoup the cost of the manipulation from the reproduction fee for a single use of the picture.

Viewing and projection

Viewing transparencies using an inappropriate light source can lead to considerable problems. Some fluorescent tubes, for example, lack red portions of the spectrum, making red subjects look dark in the transparency. Comparing prints with transparencies introduces further problems, even when you have the advantage of using good light boxes: a print on paper will never truly match a colour transparency, simply because prints have a much more limited tonal scale. However, choice of appropriate viewing conditions can go a long way to making the comparison between a print and a transparency less unfavourable. If you are in the business of assessing printed matter against transparencies, then proper viewing conditions are essential.

Light box qualities

There is now an accepted standard for light boxes, and its requirements can be summarized in reasonably simple terms as follows:

Brightness The average luminance of the light box should be 1400 candelas per square metre, give or take 300 cd m^{-2}. In English, this means that if you set your camera's exposure meter to ISO 100 and $1/250$, and place it with the lens resting on the surface of the light box, the meter should indicate an aperture between f/5.6 and f/8.

Color The light source should approximate to photographic daylight: that is to say, it should have a colour temperature of around 5000 kelvin or 200 mireds. Many fluorescent tubes meet this condition; fewer satisfy the next one.

Spectrum The light source should contain colours from all parts of the spectrum, just as daylight does. Most fluorescent tubes do not meet this criterion—this is why filtration for fluorescent light sources is often unpredictable (see page 88). Tube manufacturers specify how satisfactory a fluorescent light source is by assigning it a "colour rendering index," or CRI. On this scale, daylight has a CRI of 100, and the less satisfactory a tube is, the lower its rating. The least satisfactory fluorescent tubes have CRIs as low as 51, but for photographic use you should choose a tube with a CRI of 89 or more. Of the commonly available tubes, deluxe cool white is probably the least unsatisfactory, although it has a colour temperature of around 4200K. A better choice is a lamp specifically designed for colour comparisons, such as the Chroma 50 from General Electric. Other manufacturers make similar "colour matching" tubes.

Diffusion Light must be diffused for viewing slides, but acrylic sheet—the usual solution—generates static, scratches easily and is costly in the thickness needed. One solution is to cover a thin acrylic diffuser with thick glass, though this can tint the light box a pale green.

Comparing prints and transparencies

Comparing a reflection print or a piece of flat copy with a transparency is especially difficult, but all too common. To make an effective comparison, the print should be viewed against a neutral grey background—ideally, a surface painted 18 percent grey. The colour temperature and CRI of the light falling on the print should be the same as that behind the transparency, and an incident light meter reading taken at the print surface should indicate an exposure a stop darker than the surface of the light box.

To make an effective comparison of contrast and density, there should be a 50mm (2in) border on 3 or 4 sides of the slide, but the unmasked area of the light box should be no greater than four times the transparency area. Usually this means masking the top surface of the light box to leave a small window.

Projection distances

This chart shows the projector-to-screen distance needed to produce a metre-wide image with the most common film formats. Screen size is proportional to projector throw, so for an image 4m wide, simply multiply the projector throw by a factor of 4.

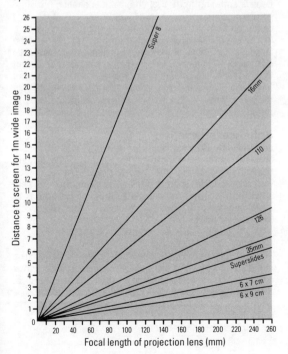

Cameras and lenses

Lens aberrations

While there is nothing you can do about lens design itself, a little knowledge of lens aberrations can help you make the most of the lenses you own. For example, knowing that curvature of field decreases as focal length increases, you might choose to set a zoom to the extreme telephoto end of its focal length range if you needed to use it for, say, flat copying or other critical work.

Curvature of field

A simple lens forms a curved image of a flat surface, and such an image will never be sharp across the width of a flat piece of film. In practical terms, this means that if you focus on the centre of the image, the corners will be unsharp, and vice versa. Stopping the lens down doesn't have the effect of making the field any flatter. What it does in fact is make the unsharp areas of the image somewhat less blurred.

Chromatic aberration

Lenses suffering from axial chromatic aberration bring the different colour components of light to a focus at different distances from the lens, producing colour fringing. Modern lenses are usually well corrected for this, but they may be less so for what is known as transverse chromatic aberration. This aberration produces images of different sizes for different colours of off-axis rays and, again, colour fringing is the visual result. The problem is most acute with telephoto lenses—fluorite elements or catadioptric design provide a solution.

Spherical aberration

Lenses with spherical surfaces bring off-axis rays to a different focus from those at the centre of the picture, blurring detail across the whole image. The aberration worsens at wide apertures, close subject distances and short focal lengths. The answer to the problem here is to avoid photographing close subjects with fast wide-angle lenses set at full aperture.

Coma

This aberration is most obvious when points of light, such as streetlamps, appear in the image—when reproduced, they appear to be smeared into comma shapes instead of circles. Stopping down eases the problem considerably. Coma affects the image progressively less toward the centre, so keep bright highlights away from the frame corners if your lens suffers from the problem.

Astigmatism

Astigmatism causes a lens to form a linear, rather than a circular, image of a point source of light—and the line changes from a vertical to a horizontal orientation as you focus the lens. Most modern lenses are well corrected for this fault, but residual astigmatism may result in vertical lines in the subject appearing sharper than horizontal ones. Again, stopping down improves the picture.

Diffraction

Most lens aberrations become less noticeable at smaller apertures. Diffraction, however, does the opposite, blurring the whole image equally. This puts a limit on how far you can profitably stop a lens down and it is a good argument for testing lenses, as explained on pages 36–7—a methodical test will reveal the optimum aperture at which other aberrations are minimized, while diffraction is still contained at an acceptable level.

Distortion

Barrel and pincushion distortions are perhaps the most obvious of all lens aberrations and they are found only in non-symmetrical designs. In extreme examples, a zoom lens may bow parallel lines away from the frame centre at the wide-angle setting, and towards the centre when set to telephoto. With fixed focal length lenses, try to ensure that there are no straight lines parallel and close to the frame edges; with zooms, testing should reveal the optimum focal length, which you can then use when control of distortion is a priority.

Lens fault	Corners worse than middle?	Longer focal length	Greater subject distance	Improved by stopping down?
Curvature of field	Yes	Improves	Improves	Yes
Axial chromatic aberration	No	No change	No change	Yes
Transverse chromatic aberration	No	Worsens	No change	No
Spherical aberration	Yes	Improves	Improves	Yes
Coma	Yes	Improves	No change	Yes
Astigmatism	Yes	Improves	No change	Yes
Diffraction	No	No change	No change	Gets worse
Distortion	Yes	No change	No change	No

Lens lore and myths

Photography certainly has its share of "old wives' tales",
but, like folklore, some of these tried-and-trusted rules can
prove remarkably useful in certain situations. Others less so.

Focusing

Dim light Focusing in dim light is especially tricky, but you
can make it simpler by using the camera as a projector.
Shine a torch through the viewfinder ocular and an image of
the focusing screen will be projected onto the subject. You
can then turn the focusing ring until the projected image is
sharp. With dim, distant subjects, place a small torch at the
subject position and focus normally; at the point of sharpest
focus the spot of light shrinks to minimum size and its
edges become better defined.

Filter *then* focus Be wary of changing anything after you
have focused and before you have taken the picture. With
zoom lenses, choose the focal length first, then focus.
When you are using a filter, focus with it in position on the
lens. If you fit the filter afterward it changes lens focal length
(and therefore the plane of sharpest focus) slightly. Even
stopping down can shift the plane of sharp focus if the lens
has residual spherical aberration. Today, thankfully, this
should cause problems only with portrait lenses manufac-
tured specifically to give controlled unsharpness.

Infrared With infrared film, don't automatically use the IR
index marked on the lens. Unless you're using a visually
opaque filter you will need to focus both IR and visible light,
so set the subject distance to a point midway between the
ordinary and IR indices.

Autofocus Experienced users of autofocus cameras are
usually aware of the type of subject that requires manual
focusing, but it is easy to forget that the autofocus sensor
locks on to the most prominent detail of the subject. Portrait
subjects wearing glasses are a particular problem, because
the camera will focus on the glass, not the pupil, and the
difference is so slight that if often passes unnoticed at the
time of exposure.

Focusing error Much of the unsharpness that is blamed on
poor lens quality should actually be attributed to focusing
error. In particular, the focusing precision of non-rangefinder
cameras declines with reduced focal length, and most of us
are familiar with the difficulty of focusing slow ultra-wide-
angle lenses. Cameras with interchangeable focusing
screens partly solve this problem, but choosing an appropri-
ate screen is not all that straightforward, because the
prismatic aids set into the screens should, ideally, be
matched to both the focal length and aperture of the lens.
As the angle of the prisms increases, so too does focusing
precision—and the accuracy with which your eye must be
centred in the viewfinder.

If you find you are having difficulties focusing, try these suggested remedies:

- Change the screen. Try a different screen from your camera's manufacturer, or a special screen such as a Beattie Intenscreen (see page 149 for suppliers) from an independent manufacturer.
- If you wear glasses, use a suitable correction lens for the camera eyepiece, but remember that the viewfinder itself incorporates some dioptre power, so the correction lens you need to use may not be exactly the same as your glasses. Also, beware if you suffer from astigmatism—turning a 35mm camera vertically may make focusing a great deal harder.
- Buy faster lenses—they are more expensive but produce a brighter viewfinder image and therefore make focusing more positive.
- Try using an autofocus camera.

Depth of field

A popular misconception about depth of field is that it is distributed in a ratio of 2:1 around the plane of sharpest focus. While it is true that depth of field extends twice as far beyond **distant** subjects as in front of them, depth of field is distributed more evenly on either side of subjects when they are positioned closer to the camera. And in close-up, the plane of sharpest focus is centred within what little depth of field there is.

In practice Depth of field calculated theoretically takes no account of lens aberrations, which always act to reduce the degree of sharpness. Since most aberrations are reduced by stopping down, you may find that at full aperture depth of field is shallower than the theory (and the markings on the lens) would predict.

Film format For a given angle of view, depth of field decreases with larger formats. To get more depth of field, use a smaller camera.

Hyperfocal distance The guide on page 56 gives you a method for calculating the hyperfocal distance, but a simple empirical way to maximize depth of field is to adjust the focus control so that the infinity symbol is alongside the depth of field marking for the aperture in use. The corresponding depth of field marks then indicate the closest part of the subject in focus.

Field of view

To predict roughly the field of view of any lens, hold a frame the size of the film format one focal length from your eye. For example, the field of view of a 200mm lens on a 35mm camera is indicated by looking through a slide mount held 200mm (about 8in) from your eye.

Quick tests for camera and lens

Testing equipment thoroughly is a task for a technician, but it is often useful to be able to check basic functions to ensure that a camera, lens or flash is working properly.

Visual inspection Start with a simple visual inspection to see whether a camera has been abused or neglected. If a camera is sold with a label stating "amateur use only", there should be very little wear at points such as the lens mount. Frequent lens changing can indicate a camera that has been worked hard, even if the paintwork is immaculate. Look at leatherette panels. If they don't fit perfectly the camera may have been repaired—worn or burred screwheads usually indicate amateur tampering.

General functioning Check that the camera or lens appears to function normally and operate all controls—even infrequently used ones.

Stopping down—consistency Open the camera back, set the smallest aperture and watch as the iris diaphragm closes down at a slow shutter speed. Shape and size should be consistent with repeated tests.

Shutter bounce test Remove the lens and fire the shutter while looking at a fluorescent light fitting, which acts as a simple stroboscopic light source. If you see a shadow at the end of the shutter's run, this probably indicates shutter bounce, which will produce an overexposed strip at the edge of the frame. Repeat the test at all shutter speeds.

Check the meter Compare readings from the camera's meter with that of another meter that you know to be accurate. Compare them in high, moderate and low light levels for a proper indication.

Flash synchronization Point a flash unit at a white wall and, with the lens in place, view the illuminated wall from the extreme corners of the film aperture at the camera back. You should be able to see the flash at all points in the frame, even at the fastest flash synchronization speed. If the camera has a leaf shutter, you should see a fully open circle when the lens is set to full aperture.

Checking lenses

If you're buying a secondhand lens originally made by a reputable manufacturer, you should be able to take it for granted that the standard of construction and design is high. However, it is worth assessing wear and damage that might have occurred as follows.

Barrel and diaphragm flare Shine a pen torch down the lens barrel to check that the lens is baffled efficiently and that repairs have not produced shiny screw heads or diaphragm blades. Hold the lens in front of a piece of white paper. Is there a lot of dirt on the lens elements? Most lenses draw dust into the barrel in focusing, but large quantities indicate that the lens has been used in a dusty

environment. Cleaning solves the problem, but see below.

Slop, grind and creep Check the action of the focusing, aperture and zoom controls. All of these should operate smoothly and positively, but the controls should not be sloppy—this indicates wear. Hold "one-touch" zoom lenses by the mount. The zoom/focus ring should not creep down the barrel.

Distortion If you are buying a lens, fit it on the camera and look through the viewfinder. Position a straight line along the edge of the frame. It should not bow in or out.

Film tests

Use colour transparency film for testing, since it has less exposure latitude. To test shutter and aperture consistency, take pictures of an evenly illuminated white wall at progressively faster shutter speeds and wider apertures, without changing the actual level of exposure. You may need to use a neutral density filter with some of the slower shutter speeds. The resulting transparencies should all have the same density and should be evenly exposed: if they are not, there's a problem with either the shutter or aperture.

To check focusing accuracy, photograph a tape measure or yardstick at an angle (so that the tape crosses the frame from top to bottom). With the camera above the end of the tape, focus on several different distances and take pictures. Check on the transparencies that the spot you focused on is the sharpest point.

Many cameras show slightly less of your subject in the viewfinder than appears on film, but the difference should not be more than about 5 percent, and the viewfinder area should mask the same border all round. To check, put the camera on a tripod and stick pieces of tape on a wall so that they appear at the corners of the viewfinder. If the viewfinder is accurate, that's where the pieces of tape should appear on film.

Lens tests

By repeating the distortion test with film, you will get a better indication of whether the lens is strictly rectilinear. You can combine this test with a sharpness evaluation by photographing a modern building: the regularly repeated architectural detail taxes the lens's ability to resolve details right across the frame. Use a heavy tripod for this test and beware of atmospheric effects—on a hot day in the city, for example, haze and heat rising soon degrades the image. Check for lens flare by photographing a bright light against a dark background. A good choice is to photograph the sun shining through a narrow gap between buildings or a light bulb in a darkened room. The images produced by many lenses have a slight hot spot that is rarely noticeable, but you can check for severe fall-off by photographing an even tone, such as a clear blue sky. The characteristic corner darkening is easy to spot on film.

Putting a figure on lens resolution

Rough-and-ready methods of testing lenses are fine if you simply want an approximate idea of how well a lens performs. However, to compare lenses objectively, it is necessary to put a figure on lens resolution. Lens testing charts provide a means of doing this.

The test chart opposite has been drawn with a particularly coarse bar pattern so that it can be reproduced immediately on a photocopier. While this makes it cheap and easy to use, there is one drawback: to get a sufficiently small image on film, the charts must be photographed from a distance of about 101x the lens focal length, or roughly about 10cm (4in) for each mm of focal length. With longer focal length lenses, this is impracticable, and you may wish to reduce the pattern onto line film and then make multiple contact prints at a much smaller scale. If you have access to a photocopier that reduces, this is a quick and useful way to make smaller charts. However, don't make repeated reductions as this will degrade the sharpness of the pattern.

Fix the charts in a row on some convenient flat surface, so that, when viewed through the camera, there is a central chart with the bars parallel to the frame edges, and two or three other patterns at regular distances out to the corners of the frame. These charts should be positioned so that one set of bars runs radially away from the center of the frame toward the corners, like the spokes of a wheel. The supporting surface should preferably be dark in colour. Make absolutely sure that the camera back is exactly parallel to the line of charts and that the charts appearing at the frame corners are equal distances from the camera, or the patterns will drift out of focus across the frame.

Use a fine-grain film, such as Kodak Technical Pan, to photograph the bar patterns. Absolute resolution is a function of both lens and film sharpness, so a grainy, unsharp film makes assessment of lens quality more difficult. You may wish to photograph the targets several times, refocusing between frames to eliminate the possibility of focusing error. Make tests at every aperture: this will enable you to determine which aperture gives optimum quality. Bracket exposures at half-stop intervals and process the film to the manufacturer's recommendations.

Evaluating the results

To determine how good your lens is, examine the best negatives with a powerful magnifier and decide which has the finest pattern visible. If you've set the camera up 101x the focal length from the chart, you can read off resolution directly. However, if you chose to reduce the chart, or picked a non-standard distance, you have to work out resolution yourself. The mathematics are simple if you have positioned the chart carefully: with the chart 21 focal

lengths from the camera you will get a 20x reduction; for a 25x reduction, 26 focal lengths, and so on. If you reduced the charts before photographing them, don't forget to take the reduction into account when you do the sums.

This process reveals a lines-per-mm figure at different points across the frame, and also indicates whether the lens suffers from astigmatism. If this fault is present, one set of bars will be sharp, while those of the same size at right-angles will be blurred. Lateral chromatic aberration may also show up as colour fringing of the bars away from the middle of the frame.

As a guide, a modern lens should resolve at least 50 lines per mm across the frame at all but the widest aperture.

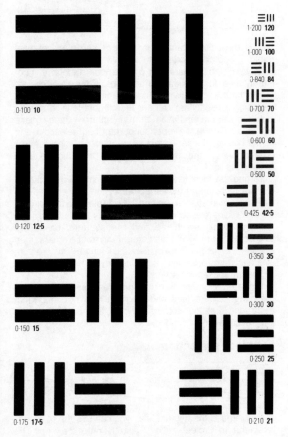

Figures in light type are actual line spacing (lines/mm)
Figures in bold type are lens resolution photographed at 101 × F (lines/mm)

Taking pictures through telescopes

Very long telephoto lenses have prices to match their focal lengths, and for occasional pictures of distant subjects at high magnifications, using some other optical instrument may be a more practicable option. Telescopes and binoculars are easily pressed into service, but unless you have the very best, don't expect the results to match pictures from a regular camera lens. Cheap binoculars in particular produce very poor pictures.

The afocal method

This is the easiest technique, since it yields a right-way-round image and works with virtually any combination of telescope or binoculars and camera lens, though a moderately long focal length camera lens is the ideal choice. Focus the telescope (we will assume from here on that you are using a telescope) and set the camera lens to infinity. Hold the camera lens about 25mm (1in) from the eyepiece and take a picture. A proper support for both telescope and camera makes the set-up less prone to camera shake, and a tube between the two is a useful precaution against extraneous light.

To find the focal length of the combination, multiply the camera focal length by the power of the telescope. If the latter isn't marked, you can find it by dividing the focal length of the main telescope element (mirror or lens) by the eyepiece focal length. To find the aperture, divide the telescope power by the diameter of the front element, then multiply the result by the camera focal length. This aperture is effectively fixed, since stopping down the camera lens simply introduces vignetting.

If one or two corners of the pictures you take are dark, then the camera lens and eyepiece are not in perfect alignment; if all four corners are dark, the camera lens and eyepiece are too far apart.

Eyepiece projection

If you remove the camera lens, you can use the telescope eyepiece to project images directly onto the film. This method provides high magnifications, but with proportionately smaller apertures, and is of limited practical

value. Additionally, viewfinder images are inverted, which creates problems for terrestrial photography. However, this is a useful method for photographing the moon in reasonable conditions.

Negative lens projection

Here you again discard the camera lens, and a negative lens attached to the telescope projects an image into the camera body. The image appears right-way-round, so composition is straightforward. Astronomical telescopes fitted with a Barlow lens are best suited to this method; if you have a good-quality Barlow lens, definition may be close to that of the main telescope lens itself. Varying the position of the Barlow lens changes the degree of magnification on film.

To find the approximate focal length of the optic, multiply the focal length of the telescope by the power of the Barlow lens. The working aperture, as on a regular camera lens, is the focal length divided by the diameter of the telescope lens or mirror.

Direct projection

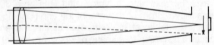

Using the telescope lens on its own, just as you would a regular camera lens, usually provides the best results of all the methods described here. However, you may find that this option is not always available with certain cheaper telescopes because of the position of the eyepiece tube. The focal length is that of the telescope lens itself, and the working aperture is the focal length divided by the diameter of the mirror/lens.

Focusing problems

Few telescope/camera combinations yield large working apertures, so with the exception of the afocal method referred to above, focusing is a problem that cannot be solved by using conventional focusing aids, such as the split-image rangefinder that features on most SLR focusing screens. However, if your camera has an interchangeable focusing screen, you may find that focusing is made considerably easier using a different type. For example, a Nikon type "C" screen has a fine-ground mat field with a clear centre spot and cross hairs, and it is ideal for focusing telescopes for astronomical and terrestrial photography.

Panoramas and panoramic cameras

In principle, making a panorama is not difficult, even with a conventional camera. The simplest technique is to shoot a series of pictures with the camera mounted on a tripod, then join them together to obtain a wider-than-average field of view. Follow these guidelines:

- Don't use a wide-angle lens. If you do, you'll need fewer pictures to make up the panorama but the change in angle between each of them will be very pronounced, and a seamless finish will be impossible. Seven frames is about the maximum for easy joins.
- Allow plenty of overlap. No lens illuminates the film perfectly evenly, and you will get smoother skies and other flat tones if you use the middle of each picture.
- Look for natural breaks in the subject that will hide the join. Utility poles are a good choice outside; inside, use columns and window edges.
- Level the tripod, not the camera. You must rotate the camera about a vertical axis or the horizon will curve up or down. Level the tripod using the legs, putting a bubble level on the centre column.
- Use the same exposure for every picture. To set exposure, take a meter reading (preferably incident light) of the most important part of the subject.
- Use camera movements to increase lens coverage along one axis. For example, a typical shift lens on a 35mm camera allows 8mm of movement left and right. Joining two pictures taken at the extremes of this movement produces a distortion-free image of 24x52mm (1x2in).

Panoramic cameras

Panoramic cameras greatly simplify taking ultra-wide pictures. There are three different camera geometries available—each has its own advantages and drawbacks.

	Conventional: fixed lens, fixed film	Lens rotates about rear nodal point; static film in curved plain	Camera rotates while film advances past slit
Example	Linhof Technorama	Widelux	Alpa Roto
Field of view	Typically 90°	Typically 150°	Unlimited
Linear distortion	None—save that of any wide-angle lens	Parallel lines bulge apart	Parallel lines bulge apart
Shutter speeds	Normal range	Limited—can't be used in dim light	Limited—can't be used in dim light
Moving subjects	Appear normal	May be distorted if direction and speed match that of lens	May be distorted if direction and speed match that of camera rotation
Notes	Needs centre graduated ND filter to compensate for light fall-off at corners		Hard to find subjects to surround camera. Photographer appears in picture.

Camera and lens care

Modern cameras are so sophisticated that they are virtually impossible to service without the skills of a highly trained engineer. Even preventive maintenance is largely limited to keeping the camera clean.

It is best to clean the camera exterior with a stiff brush, such as a 25mm (1in) paint brush. Clean the film chamber using a bulb syringe or a can of compressed air. Take care, though, not to touch the shutter or blast it with air. Wipe the pressure plate with a tissue moistened with alcohol after you've brushed out this area. If you use a soft brush to clean the film compartment, make absolutely sure that none of the hairs come adrift. The fibres frequently find their way into the camera's focal plane, casting a shadow on every frame of film you expose.

Clean out the mirror box in a similar way, holding the camera overhead so that dust drops out of the camera and not onto the mirror. On a new camera, you may need to use a small brush to remove the tiny filings of metal that are sometimes shaved off when mounting or removing lenses. Raise the reflex mirror (either with the mirror lock control, or by setting the shutter to "B" and pressing the shutter release) and blow air into the area normally hidden behind the mirror. Again, take care not to damage the shutter blinds in any way.

Dirt on the focusing screen is irritating but essentially harmless, so don't remove and clean the screen in field conditions if you can possibly avoid it. When you remove the screen, take care not to touch its surface with unprotected fingers, since marks are difficult to remove.

The reflex mirror of an SLR is extremely fragile. Its silvered surface scratches easily and the mirror mounting is easily damaged. Dirt on the mirror, like dirt on the focusing screen, has no effect on the picture, and simply causes viewfinder flare. So **don't touch the mirror** except as a last resort. If you must clean marks off the mirror, blow and brush before wiping. Then use a moistened swab wrapped around the handle of a fine paint brush or a thin stick of some other sort. Ideally, though, leave this delicate task to a qualified technician.

Cleaning lenses

The fragile surface of a photographic lens deserves considerable respect. Before wiping a lens with your shirt tail, remember that each layer of the anti-reflection coating is the thickness of only one wavelength of light. Clean lenses by first removing as much dirt and dust as possible with a bulb syringe or blower brush. Cans of compressed air are effective, but if you tilt the can there is a risk that its contents may be discharged in liquid form, and this can irreparably mark the lens surface. When dusting off the rear

element of the lens, focus the lens on infinity to reduce the risk of dirt being blown inside the lens mechanism.

· If possible, remove marks without using a solvent. Instead, roll up a tissue and tear the roll in half, using the torn end to wipe the lens. First wipe around the edge of the lens then gradually work toward the centre. For stubborn grease marks and fingerprints, use an approved optical solvent—don't improvise—or a moist lens wiper.

Checks and preventive maintenance

The most valuable preventive maintenance ironically consists of the most obvious precautions—replacing the camera batteries regularly. This is such a mundane, self-evident task that many of us forget to do it. Change batteries annually or more often, preferably on a fixed date that is written in a diary or on a calendar. (Don't choose a celebration or anniversary day.)

Before departure on an important photographic trip, replace camera batteries with new ones whether they need them or not, and check the camera thoroughly. In particular, check that the diaphragms are functioning reliably on all lenses. Repair technicians report that diaphragm failure is a common problem, and especially disastrous because it often passes unnoticed on location. Only after processing does the photographer become aware of the problem.

Camera failure

If a camera does not work, don't panic. There is probably a very simple explanation. Many cameras have controls that are infrequently used, and if you have operated one of these inadvertently, the camera may well perform in an unpredictable manner, or not perform at all. For example, the "count-down" frame indicator on a motor drive has caused many anxious moments—unless it is set for unlimited shooting the camera simply stops functioning after a pre-set number of frames has been exposed. (There is a simple way to avoid this problem—tape over controls you don't use all the time.)

After simple procedural errors, the biggest gremlin is battery failure. Virtually all cameras are now dependent on battery power and few incorporate battery check controls. To prevent unreliable operation as batteries weaken, many pro-quality SLRs now lock up, with the mirror raised, when the cell voltage drops below a threshold level. Even a fall of $1/20$ volt can cause the camera apparently to jam, so suspect the battery first.

Following the procedures listed below should reveal the source of most 35mm SLR problems that don't require the services of a technician. Some of the suggested steps have been deliberately made extremely simple because it's easy to overlook the obvious when you're under pressure. You may wish to skip some steps to save time, but if you've no

idea where the problem lies, starting at "A" and working through should provide you with an answer by a process of elimination. For field servicing, you will find it useful to pack the "toolkit" shown on page 47.

In following these check-out routines, treat the camera very delicately and never use force to operate controls. Japanese camera manufacturers have been quoted as saying that they designed for "strong European fingers", but no camera can stand up to abuse. Always use the absolute minimum of effort: if the camera doesn't respond, further pressure may easily cause damage.

A General operational checks

A1 Check that film is not at an end and that film rewind controls are not engaged. Cycle camera power off and on. Switch on motor drive and set it to single frame.

A2 Check that the lever wind is in the correct position for normal operation and, with manual film advance, that the film wind cycle is complete.

A3 Check that the self-timer, double exposure control, exposure compensation, battery check, depth-of-field preview and mirror lock controls are set to normal position. Confirm that the frame counter shows 1 or above and that the shutter is not set for long time exposure. If it is, set it to an instantaneous exposure time or a manual speed.

A4 If the camera has a manual shutter scale, operate it at fast and slow speeds, and audibly confirm normal function. If the camera has a manual aperture control, set it to the smallest aperture, set the shutter speed to ¼ or slower and confirm that the iris closes fully and re-opens smoothly.

A5 Set the camera to automatic, film speed to 100. Direct the lens at a bright target and confirm fast shutter speed/small aperture. Repeat this with a dim target. Confirm slow speed/wide aperture.

A6 Check the meter with the "Sunny f/16" rule (see page 64).

A7 If there is film in the camera, remove it and supplement A4 with visual checks.

If the camera fails any of these tests, suspect electrical failure first and proceed to B.

B General electrical check

B1 Remove the motor drive if it is fitted and set the shutter to its mechanical speed (usually X).

B2 Advance the film manually and release the shutter.

Camera functions correctly?
Yes: faulty camera cells—proceed to C.
No: mechanical problem—proceed to E.

C Camera cell failure check

C1 Remove the motor drive if fitted.

C2 Remove the cells and clean the battery contacts and compartment.

C3 Confirm the battery type needed from the information found on pages 139–40.

C4 Confirm that cell polarity is correct and replace the batteries.

C5 Cycle power on and off.

C6 Confirm correct operation.

If the camera fails, repeat C3-C6 with new cells in the camera.

If the camera fails again, suspicion falls on a mechanical or a serious electrical problem of some type and proceed to E.

If the camera passes C1-C6 and the motor drive is in use:

C7 Replace the motor drive.

C8 Confirm correct operation. If the camera fails, suspect the motor drive and proceed to D.

D Motor drive cell failure check

D1 If there is a battery check indicator on the motor, use this to determine the state of charge.

D2 If the drive has a decremental frame counter for shooting sequences of pre-set length, make sure this is set for unlimited shooting.

D3 Remove the motor drive from the camera and clean the contacts on both the camera and the drive.

D4 Remove the cells from the drive and clean the battery contacts and compartment.

D5 Remove the battery holder and clean the terminals of the holder and compartment in the motor drive. Remove the cells from the holder and clean the battery contacts and compartment.

D6 Confirm the battery type from the information given on pages 139–40. Also, confirm polarity and replace the cells in their holder. Place the holder in the drive and cycle power on and off.

D7 Short the terminals with a coin to complete the cycle. If you can't do this easily, don't try using a piece of wire, or you could short the camera's battery pack and possibly cause permanent damage.

D8 Advance the film wind on the camera and attach the motor drive.

D9 Confirm A checks for correct operation.

If the camera fails, repeat D6-D9 with new cells.

If the camera still fails, but passes C checks, the fault is in the motor drive.

E Mechanical failure
E1 Perform the electrical check as above.
Only then
E2 Carry out a visual check for mechanical obstructions—open the camera back and look for any film chips; check the camera exterior for loose or missing screws; remove the lens and (if possible) prism and focusing screen and check the interior of the mirror box for anything out of the ordinary.
E3 Remove the lens. If the mirror is up, **very gently** press the mirror mounting upward in the direction of the focusing screen.
E4 Holding the mirror in place **very gently**, press the camera shutter release.
E5 Again very gently, lift and release the diaphragm actuator lever.

If all of these checks fail and the camera still does not operate, you will need to seek professional help from a qualified technician.

Coping with crises
The best cure for camera failure is to carry a spare body that is compatible with the lenses you use. The trade-in value of a five-year-old camera that has had professional use is almost negligible, even if the camera works perfectly. So instead of handing over an old camera in part exchange for a new model, consider retaining the obsolete body as a spare.

The list of camera crises below is by no means comprehensive, but it includes the problems most commonly encountered by repair technicians.

Spilt drinks
Small spills may not be disastrous. What usually counts is the quantity of dissolved solids, especially sugar. Remember that technicians use neat alcohol to clean camera components, so if you spill strong vodka, don't worry. Sweet tea, on the other hand, could wreak havoc with the camera's moving parts. There is little you can do to salvage the situation, apart from removing as much moisture as possible from the camera exterior and drying any removable parts, such as the lens or prism. Moisture is sucked into the camera's components by capillary action, so pay special attention to gaps and crevices, such as where the bottom cover of the camera joins the main chassis.

Grit in lens focusing mount
Just one particle in the lens focusing mount is sufficient to make a grinding sound, but damage in the short term is unlikely to be serious. Clean the camera exterior of all grit and dirt and continue shooting, but have the lens stripped down and cleaned as soon as possible.

Mechanical damage

If you drop a camera you may be able to make it work with the aid of gaffer tape. Damage to the camera back is common, especially if there is pressure on the flimsy back as you change film. Try to bend the back into the closest possible semblance of its original shape, then tape it firmly into place.

The lens tends to bear the brunt of most knocks, and if the bash distorts the lens mount you may not be able to remove the lens. If you can, check the diaphragm actuator if it is mechanical. Does it move? If so, try mounting the lens and gently operating the stop-down lever. Does the lens stop down? If it does, you may be able to continue shooting. If the lens fails both these checks, though, don't try pressing the shutter release, or you could further damage the camera. Even if the lens does stop down, the mechanism that transfers aperture information to the camera body may be faulty, so check that the meter appears to work normally. To be sure, operate the camera on manual and use a separate meter.

Smashed filters are another common casualty. Hold the lens filter downward, and remove as much of the broken glass as you can. Often the filter has a retaining ring that you can loosen or remove to make this easier. A bent filter ring will almost always jam on the lens.

Thumb through shutter blades

This is a common problem when you are struggling to change films under pressure. It is especially prevalent with the newer breed of cameras that have a top shutter speed of 1/2000—the blades of these shutters are made of very low-mass material that is literally wafer thin and therefore prone to damage.

If you damage the shutter, **don't try to advance the film,** since this may make the situation worse. Remove the motor drive and assess the situation. If the shutter was cocked when you damaged the blades, the camera is probably useless. However, if you damaged the capping blinds, which cover the film after exposure until the shutter is cocked again, there may be some hope. If you can, take the camera immediately to a technician. However, if you have to continue using the camera body, try this: ease the free ends of the blades back into their tracks and press them flat. Then try cocking the shutter and pressing the shutter release. If the shutter appears to function, press the shutter release and then open the camera back and remove the lens. Lift the mirror, either with the camera's mirror lock-up or with the tip of your little finger. Look through the shutter blades. If you can't see daylight, the capping blinds are functioning. If you can see cracks of light, you may be able to manage using a motor drive, which re-tensions the shutter immediately following exposure. However, bear in

mind that this is a very last resort, and by trying it you may destroy the shutter. By way of a consolation, it is worth knowing that shutters damaged in this way are usually replaced as a complete unit, so whatever you do can hardly make things any worse.

Immersion in salt or fresh water

Unless your camera is capable of functioning without electrical power, a dunking may prove final. One technician, asked for advice on a camera that had been submerged, commented: "Check your insurance cover, then throw the camera back into the ocean." Cameras that are completely or largely mechanical may be worthwhile repairing, but the vast majority of modern cameras are essentially destroyed by water of any description. The traditional advice about salt water was to immerse the camera immediately in fresh water, but this is now of extremely doubtful value, since water of any type destroys the electrical circuits on which the camera relies.

Film is another matter. If the camera contains valuable exposed film, get to a darkroom or changing bag as quickly as possible, remove the film from the cassette or backing paper and immerse it in fresh water. (On location, you may wish to carry a developing tank for this purpose.) Then you can wash and dry the film in total darkness prior to processing it in the normal way.

Troubleshooter's toolkit

Everybody accumulates a selection of non-photographic "first aid" items that help in fixing cameras. This general list makes a good starting point.

1 Spare set of **new** cells for camera, motor drive and flash
2 Coin to get camera battery cover off
3 Battery meter, such as a pack-flat LCD model
4 Pencil-type eraser for cleaning inaccessible contacts
5 Stiff brush to remove dust from camera exterior
6 Soft brush for lens cleaning
7 Compressed air can or bulb syringe
8 Moistened lens wipes
9 Cotton wool buds to clean camera eyepiece
10 Jeweller's screwdrivers
11 2 × filter wrenches, or two lengths heavy electrical cable (not flex) to remove jammed filters
12 Swiss army knife
13 Torch
14 Electrical/duct/gaffer tape
15 Rubber bands
16 18% grey card to test meter
17 Spare parts—eyepiece, filters, flash synch cord, lens and body caps
18 Spare camera body

Hazards to equipment

Modern cameras are robustly built and not prone to
malfunction, but most are designed to operate best in
temperate climates. If you are forced to work in uncomfort-
able, or downright dangerous, conditions, you must take
steps to protect your camera. You might be surprised at
how commonplace the hazards described here are.

Cold climates—mechanical problems

As a general principle, choose simple equipment if possible:
rangefinder cameras, for example, have fewer moving
parts, and are therefore less likely to go wrong than
mechanically complex SLRs. Metal shutter blinds perform
better in very cold conditions than fabric ones, which
become stiff and possibly brittle. Both types, though, are
likely to slow or perform erratically in extreme cold. Modern
oils have made the "winterizing" of cameras unnecessary.

Generally speaking, newly bought cameras function
better in the cold than old ones, and most good-quality
professional cameras should present few problems at
temperatures down to –30°C (–22°F). If you want to check
on your camera's resistance to cold, load it with film, wrap it
in a plastic bag and chill it in the freezer. For the "Big Chill",
add dry-ice pellets. Operating the camera in the normal way
(inside the bag) should highlight potential problems.

Choice of lenses presents a dilemma. Changing lenses is
a hazardous operation in cold conditions, which would seem
to give zooms the edge. However, zoom lenses are liable to
become sluggish and hard to operate in the cold. This is
most apparent with cheaper zooms, which are packed with
grease for smooth operation. Motor drives, too, have both
advantages and drawbacks in the cold. In moderately cold
conditions, a motor drive is an advantage, because many
cameras draw current from cells that power the motor. AA
cells cool more slowly than a button cell in the camera base,
so you can carry on taking pictures for longer. But in really
cold weather, a motor drive can snap the brittle film.

Adapting equipment

Bare skin freezes to metal, so use fabric tape to cover all
metals parts that you might touch with your face or bare
hands. A UV filter provides valuable protection from snow
and ice: it is easy to replace an iced-over filter, but if ice
forms on the front element of a lens the solution is less easy
to find. In bright, icy conditions, you may have to wear
sunglasses, so check that you can see the whole finder
screen when wearing them, or use an "action" or high-
eyepoint finder. Fiddly camera controls are a special
nuisance when you are wearing two pairs of gloves, and so
you may wish to have a camera mechanic enlarge frequent-
ly used knobs and buttons.

Batteries and cells All electrochemical reactions slow down as the temperature falls, and NiCads give only 60 percent of their normal capacity at −20°C (−4°F). The cells can be permanently damaged when recharged at temperatures below 10°C (50°F). Primary cells fare little better. If possible, keep batteries in a "cold clip"—a separate battery holder tucked inside a warm pocket and linked to the camera by an insulated cable. For less elaborate excursions in snow and ice, just take several sets of cells and keep switching them from the camera to a warm pocket. Remember that some cameras function without cells. You may want to take a mechanical camera and a selenium light meter as precautions.

Film At very low temperatures film becomes brittle and is liable to break. The risk of breakage can be reduced by winding-on slowly and by changing film before the end of the roll. Cold air is also very dry, and this encourages static electricity to build up, and then discharge, causing characteristic "lightning-bolt" fog marks. Some Arctic veterans favour Kodachrome because it has a unique backing layer that dissipates static charge, but others choose negative film because its broad exposure latitude soaks up all but extreme exposure errors.

Working methods

Equipment and film problems are minimized if you keep everything warm. Bulky outer clothing gives ample space for incubating a clutch of cameras, and there are various methods of actively heating equipment. Hot-pads, available from sports stores, can be strapped to the camera with tape and provide a trickle of warmth for an hour or two. Electrically heated clothing can be adapted to photographic use—a few photographers wrap their cameras in electric socks for cold-weather excursions.

Icing of equipment is a major hazard, and the photographer's own breath is the principal source of ice. If snow lands on the lens, don't try to blow it off or a layer of ice will cloud the glass. Don't change lenses when you are panting after exertion, because ice forms on the camera's reflex mirror. Likewise, unprotected rear lens elements are especially vulnerable to icing. Your breath doesn't just cause icing—it can spoil pictures, too, so hold your breath for a couple of seconds before pressing the shutter release.

Paradoxically, icing hazards are at their worst when equipment warms up. Condensation that forms on cold equipment in a warm room can later freeze a camera solid. When moving from cold to warm conditions, wrap everything in plastic bags until it has warmed up.

Rain and spray

The best protection against wet-weather hazards is avoidance. But in some climates torrential rain is a fact of life, and

wet weather often produces some spectacular lighting conditions. Equally, salt spray is inevitable near the coast in all but the calmest weather.

Equipment

Preparing equipment for use in wet weather is inevitably a compromise between protection and ease of use. Improvised solutions keep out showers, and ready-made protection runs from rain-capes and flexible PVC camera bags up to fully blown underwater housings that will withstand tropical storms. If you are using flash, take special care to waterproof the unit. The high voltages inside the unit can create a considerable spark if water leaks in. Ideally, use a self-contained hammer-head unit wrapped in plastic.

To improvise a waterproof cover for your camera, use a heavy-gauge, clear-plastic bag, and cut a hole just big enough to accommodate the hood of the lens you are using. Cut a second hole for the camera eyepiece. A rubber band will hold the bag tightly around the lens, and the second, smaller hole can be held in position by the rim of the viewfinder eyepiece.

Working methods

It is as well to assume that water will find its way into everything. Put camera bags down on dry plastic sheets or, better still, hang them up on the tripod. If there's a risk of rain or sea spray soaking equipment, don't rely on a single layer of polythene—double-bag everything. Equipment inside four or five layers of plastic will even survive total immersion for a few minutes, so this is a wise precaution if you have to make an impromptu trip in a small boat.

If equipment is soaked, get the worst of the water off immediately, but leave a thorough drying until you are out of the rain or spray. The exception to this rule is water on the lens, which actually impairs performance. Rain and fresh-water spray just wipes off, but to remove salt spray you'll need to use a tissue moistened with fresh water, so it is worthwhile carrying a small bottle of this with you.

When drying equipment, pay special attention to hard-to-reach parts of the lens. Rack the lens out to the closest focusing distance and dry the exposed portions of the barrel that are concealed when the lens is focused on infinity, then turn the focusing ring back to a distant setting.

Dust, sand and grit

Even a brief exposure to sand's abrasive qualities is enough to render a good camera totally useless, but some cameras are more resistant than others. When choosing equipment, look critically at the seal against dust. Manufacturers are becoming more aware of the problems caused by the ingress of particles, but some cameras still have yawning gaps through which particles can enter. Seal these with

adhesive tape where possible, and for regular work in really dirty conditions, consider an underwater camera.

Working methods

Planning helps to keep cameras and lenses clean. Keep the camera packed away until you have to get it out to take pictures—don't use it just to preview possible shots. Advance film gradually: don't snatch at the lever wind and don't use a motor drive. The rapid movement of film generates static electricity, which attracts dust and grit. For similar reasons, wear clothes made of natural fibres.

Keep the front element of lenses clean with a skylight filter, and clean equipment whenever there is an opportunity. Use brushes, a bulb syringe, an air-line or a can of compressed air, following the instructions on page 40. Take care not to blow dirt into inaccessible places.

Think very carefully before you put the camera down because "clean" surfaces may in reality be coated with fine dust. With careful planning, you should be able to reduce film and lens changing to a minimum. Zooms make lens swapping less frequent, and you can cut down film changing by using 220 rather than 120 roll film, or a 6x4.5 format camera rather than 6x6. With roll film cameras that accept interchangeable backs, hire extra magazines so that you don't have to open the film compartment.

At the end of the day, clean everything, preferably with a vacuum cleaner (but avoid delicate shutter mechanisms). Segregate clean and dirty equipment and pay special attention to the corners of bags and cases.

Heat

Working in very hot conditions is probably harder on photographers than it is on cameras, but there are still photographic problems to be solved. In particular, hot conditions cause rapid deterioration of film. Store film in a refrigerator if possible, or in an air-conditioned room, and take out only enough for one day's shooting. Allow time for film to warm up (see page 24) before removing it from the inner packaging. If you can't find a refrigerator, and you can't afford an air-conditioned hotel, pack film in the middle of a suitcase and remove the protective layers of clothing only at night. If you normally use "professional" films, you should instead consider shooting on freshly bought "amateur"-designated film. This film has not reached peak condition when sold, so after some exposure to heat the film may well give better results than "ripe-at-sale" professional film.

On location, keep film in an insulated box, with cold-packs for added chilling. Frozen tins of beer make a good substitute—choose the strongest brand of beer, since weaker brews freeze at a higher temperature. After exposure, return the film to cool conditions and process it as soon as possible.

Cameras and lenses The most noticeable effect of heat on the camera body is a change in the liquid-crystal display, which rapidly goes blank. Fortunately the change is reversible, but some newer cameras provide virtually all information through LCD panels. If possible, use a camera that communicates via old-fashioned dials or light-emitting diodes (LEDs).

Use lens caps when lenses are not in use, since uncovered lenses focus the sun's rays inside the camera. Though SLRs deflect the beam with a mirror, many "steal" a little of the light for autofocusing or exposure metering at the focal plane. The electrical components that perform these functions may possibly be damaged if subjected to prolonged exposure to an intense image of the sun. If you are using a large-format camera, stitch a piece of reflective mylar on the back of the focusing cloth to reflect the worst of the sun's rays.

Working methods
Keep equipment cool in whatever way you can. Some precautions are obvious, others less so. When renting vehicles, pick a light colour whenever possible—perhaps book well ahead so that you have the option. Carry equipment on the floor of the vehicle behind the front seats, but check where the exhaust pipe runs or you could cook your cameras and lenses. Never leave equipment in an unshaded stationary vehicle, as the temperature soars in the sun to levels that can cause lens elements to loosen and separate.

Outside, use reflective-finished, rigid camera cases where possible or cover the camera bag in reflective material. A wet white towel over a layer of polythene reflects light from the bag and cools by evaporation.

Humidity
Heat and humidity frequently go hand in hand, and the combination is especially damaging to film, causing more rapid deterioration than either of the two hazards separately. Note that these comments apply only to **visits** to humid areas. If you are permanently relocating to a humid climate, seek far more detailed advice from camera, lens and film manufacturers.

Protecting film
In high humidity, the gelatin emulsion of film swells and become sticky and, if exposed to these conditions for long enough, can jam the camera. Humid conditions also encourage the growth of fungus that eats away at the gelatin. Keep film sealed in its original packing for as long as possible and consider using short rolls to cut down the time that one particular film stays in the camera. After exposure, don't seal the film up again. Instead, put it in a dry place,

such as an air-conditioned room, to vent some of the moisture. If this is impossible, leave the film in a ventilated place, rather than sealed up.

If there is a delay before processing, seal film into an airtight container with some packets of desiccant, such as silica gel. This will draw some of the water out of the film, so preventing serious deterioration. Cans or plastic boxes make good containers, but plastic bags are more compact, and you can suck out excess damp air before sealing. Don't overdo the drying: dehydration is as damaging to film as saturation. Follow the guidelines in this chart to reach a happy medium. Quantities of desiccant are for an 8-litre (14-pint) container.

Film format	Quantity of Desiccant	Drying time
20 cassettes 35mm film	30gm (1oz)	2 weeks
20 rolls 120 film	150gm (5¼oz)	2 weeks
10 sheets 5×7in film with interleaves & stiffeners	30gm (1oz)	1 week

Saturated silica gel can be "recharged" by baking it in an oven at gas mark 6 or 200°C (400°F), and the most useful types have a coloured indicator dye to show when this is necessary. If you can't find silica gel, oven-dried tea leaves or uncooked rice make an acceptable emergency substitute. You will need large quantities, however—about eight times the amounts listed above.

Protecting equipment

Damp conditions, if prolonged, can damage electronic components. Even in the short term, humidity causes rapid oxidation, so keep a constant check on battery contacts, cleaning them if necessary. Electronic flash is particularly at risk because the high voltages inside the units short out more easily than the low voltages at which most other apparatus works. Take special care to dry flash units carefully, and perhaps take expendable flashbulbs if you are dependent on this source of light.

Working methods

Keeping yourself dry in a humid climate is all but impossible, so aim instead to prevent any dampness falling on the camera. Wear a towelling head-band to prevent perspiration dripping onto the camera, and keep a dry cotton towel handy for wiping your face and hands. If the camera does become damp, dry it off as soon as possible.

Don't leave film in the camera—unload it as soon as you have finished shooting, and always at the end of the day. Clean and dry your equipment methodically at the end of a day's photography and leave everything out to air—don't put cameras and lenses away in cases and bags.

Image calculations

You can use the guides printed on the pages that follow with no knowledge of photographic principles. Though the source formula is shown in many instances, you don't need to know the theory to make the sums work. The emphasis here is on practical photography not on the niceties of the classroom, so the worked examples reflect typical working methods. Hopefully, with the aid of these guides, you won't find yourself arriving at a location without the lens you need, or discovering at the last minute that, no matter how much you stop the lens down, you can't get the client's house and flowerbed in focus in a single shot.

Different pocket calculators work in slightly different ways, so you may find that you need to make small changes to the procedures shown here. In particular, the method of clearing the memory differs from one machine to another. I've assumed you are using a calculator with a separate recall memory and clear memory keys. Some calculators have just one key, and pressing it twice erases the memory.

The shaded boxes in the guides indicate the calculator's function keys that you press; the middle column indicates the parameters or variables you will need to key in; and the final column shows a worked example. If you get an answer that seems wrong, run through the worked example to check that you are not making an error in data entry.

The commonest mistake is to use the wrong units. The examples have been given in metric units because focal length appears in most calculations, and most lenses have their focal lengths stated in millimetres.

Sharpness calculations

Parameter	Symbol	Calculator number				
		1	2	3	4	5
Circle of confusion	c	?	●	●	●	
Film format/image size	v	●				
Print size	S	●				
Print viewing distance	D	●				
Nearest point in focus	d_n		?			?
Farthest point in focus	d_f			?		?
Subject distance	U		●	●		●
Focal length	F		●	●	●	
f-number	f		●	●	●	
Hyperfocal distance	H				?	●

The symbols shown are those used where a formula is quoted; "?" indicates the object of the calculation in each case. Film format and image size are used interchangeably, because some calculations seek the size of subject that will fill the frame—usually the meaning is clear in the examples from common sense.

1 Circle of confusion

The aptly named circle of confusion is a handy constant that is used in many optical calculations. It is a measure of how clearly we see photographic images. To the average viewer looking at a contact print at normal distances (usually 250mm), a circle 0.25mm wide appears as a point. Objects made up of such tiny circles look sharp, but if the circles are any bigger, the contact print appears blurred. The circle of confusion is the size that points on the film must not exceed if this criterion for sharpness is to be satisfied. Thus, for contact prints or instant pictures, the circle of confusion equals 0.25mm. However, if you intend to enlarge the film image, or view it more closely, then the circle of confusion will become smaller:

$$c = (v \times D)/(1000 \times S)$$

For example, how big should the circle of confusion be for a 35mm negative that will be enlarged to make a 20 × 25cm (8 × 10in) print and viewed at normal distances?

Keystroke	Parameter	Example
AC	1000	
×	Print width (mm)	250
M+	Negative width (mm)	36
×	Viewing distance (mm)	250
÷ RM =	Circle of confusion (mm)	0.036

Most optical calculations assume fixed values for the circle of confusion, and unless you plan to make billboard-sized prints to be viewed close-to, you can use figures of 0.036mm for 35mm film, and 0.056mm for roll film.

Depth of field

The nearest and farthest points in focus can be calculated in a number of ways. The most common formulae are:

$$d_n = U \times F^2/[F^2 + (U \times c \times f)] \text{ and } d_f = U \times F^2/[F^2 - (U \times c \times f)]$$

For example, how much depth of field is there when a 50mm lens is focused on 10m, at an aperture of f/4?

2 Nearest point in sharp focus

Keystroke	Parameter	Example
AC	Focal length (mm)	50
×	Focal length (mm)	50
M+	Point in focus (mm)	10,000
×	Circle of confusion (mm)	0.036
×	Aperture	4
M+	Point in focus (mm)	10,000
×	Focal length (mm)	50
×	Focal Length (mm)	50
÷ RM =	Result	6345.1776mm

3 Farthest point in sharp focus

Keystroke	Parameter	Example
AC	Focal length (mm)	50
×	Focal length (mm)	50
M+	Point in focus (mm)	10,000
×	Circle of confusion (mm)	0.036
×	Aperture	4
M-	Point in focus (mm)	10,000
×	Focal length (mm)	50
×	Focal Length (mm)	50
÷ RM =	Result	23584.905mm

Subtracting one from the other gives the depth of field—
about 17m or about 56ft.

4 Hyperfocal distance

If you focus the camera on infinity, depth of field beyond this
imaginary point is "wasted". Hyperfocal distance allows you
to utilize this wasted depth of field. When the lens is
focused on infinity, the hyperfocal distance is the closest
point in sharp focus. Set the lens to the hyperfocal distance
and everything will be sharp from infinity to half the
hyperfocal distance. Setting the lens to the hyperfocal
distance thus allows you to focus as close as possible while
keeping distant subjects sharp.

Hyperfocal distance $H = F^2/(f \times c)$

Where should I focus to get maximum possible depth of field in a scenic view with a 35mm lens and an aperture of f/11?

Keystroke	Parameter	Example
AC	Focal length (mm)	35
M+ × RM ÷	Aperture	11
÷	Circle of confusion (mm)	.036
=	Result	3093.4341mm

The result is in mm, so focusing about 3m or 10ft away gives the best overall sharpness.

5 Quick-and-dirty depth of field

If you know the hyperfocal distance for a particular combination of lens and aperture, you can find the nearest and farthest points in focus very easily, using these formulae:

$$d_n = (H \times U)/(H + U) \text{ and } d_f = (H \times U)/(H - U)$$

The following example uses figures from the earlier depth of field calculation; hyperfocal distance, 17,361mm, was calculated as set out above. Calculating the nearest point in focus first:

Keystroke	Parameter	Example
AC	Hyperfocal distance	17361
+	Point in focus	10,000
M+	Hyperfocal distance	17361
×	Point in focus	10,000
÷ MR =	Result	6345.1628

Then the farthest point in sharp focus

Keystroke	Parameter	Example
AC	Hyperfocal distance	17361
	Point in focus	10,000
M+	Hyperfocal distance	17361
×	Point in focus	10,000
÷ MR =	Result	23585.110

As you can see, these results are very close to the figures for depth of field derived using the more precise method explained earlier, and in practice the hyperfocal distance method provides satisfactory accuracy in almost all instances, with far fewer keystrokes.

You may also notice that the keystrokes required to calculate the nearest and farthest points are almost identical—only one step is different. You can thus make the calculation very much quicker if you jot down an intermediate result on a piece of paper.

There is unfortunately no quick and easy way to calculate the aperture required for any given depth of field—the best answer is to make an educated guess, then use the guides as shown above to home in on a precise figure.

Image size calculations

Parameter	Symbol	Calculator number		
		1	2	3
Film format/image size	v	•	•	•
Subject distance	U	•	•	?
Focal length	F	•	?	•
Subject size	u	?	•	•

Field of view, subject distance, image size, lens extension and focal length are linked by these rules:

$$1/V + 1/U = 1/F \text{ and}$$
$$M = v/u = V/U$$

1 Finding field of view

Using a 200mm lens, how much of the frame will the Eiffel Tower fill when seen from Sacré Coeur, 4.7km (nearly 3 miles) away?

Keystroke	Parameter	Example
AC	Subject distance (mm)	4,760,000
÷	Focal length (mm)	200
−	1	1
×	Film format	36
=	Result	856,764mm

. . . or 856m, so the 300m tower fills under half the frame.

2 Choosing focal length

Given that I can afford only the cheapest seats at the tennis tournament, some 41m (135ft) from the net, which lens will I need for a landscape format head-and-shoulders shot of Nastase as he abuses the umpire?

Keystroke	Parameter	Example
AC	Subject size (mm)	say, 1000
÷	Film format (mm)	36
+	1	1
M+	Subject distance	41,000
÷ RM =	Result	1424.7104mm

Buying (or even hiring) a new lens is thus a less practicable option than buying better tickets.

3 Minimum working distance

I'm looking for a new studio. How much unobstructed length do I need for a full-length portrait on a 105mm lens?

Keystroke	Parameter	Example
AC	Subject size (mm)	2000
÷	Film format (mm)	36
+	1	1
×	Focal length	105
=	Result	5938.3333mm

In other words, about 6m or 20ft.

Macro calculations

The guides that follow enable you to evaluate most of the factors affecting macrophotography. However, the guides assume that the lens is paper thin. In earlier calculations this was a safe assumption because the subject distances were many times greater than the thickness of the lens. However, at macro scale, *nodal separation* may rear its ugly head. Nodal separation increases or reduces the lens extension needed to create any particular magnification. If practical tests yield lens- or subject-to-film distances that contradict the keystroke guides, carry out this simple test to measure its nodal separation. Set up the camera to produce a 1:1 scale of enlargement, preferably checking magnification by holding a ruler in the focal plane to eliminate viewfinder magnification. Now measure the film-to-subject distance. For zero nodal separation, it should be four times

the focal length. Any deviation from this is the nodal separation, and for precise work you should take it into account when calculating bellows extension. With the exception of zoom lenses, nodal separation is fixed and always acts in the same sense—for example, whatever the magnification, you will always need to add or subtract the same amount.

Parameter	Symbol	Calculator number					
		1	2	3	4	5	6
Film format/image size	v	●	●	●			
Focal length	F	●	●				
Lens-to-film distance	V	?					
Subject size	u	●	●	●			
Magnification (v/u)	M				●	●	●
Film-to-subject distance	D		?				
Exposure compensation	E						
symmetrical lenses				?			
non-symmetrical lenses					?		
ditto reversed						?	
Pupillary magnification factor	P				●	●	
Aperture	f						●
Circle of confusion	c						●
Depth of field	t						?

1 Bellows extension

$$V = F \times (v+u)/u$$

For example, how much extension is needed to make a 10mm long beetle fill the frame width, using a 50mm lens?

Keystroke	Parameter	Example
AC	Film format (mm)	36
÷	Subject size (mm)	10
+	1	1
×	Focal length	50
=	Result	230mm

This gives the total extension needed. Broadly speaking, when focused on infinity, all lenses are one focal length from the film, and the focusing mount provides some additional extension (which you can measure with a ruler) for focusing on closer objects. Subtracting these extensions from the calculated figure gives the additional length of bellows or extension tubes needed in order to produce an image of a particular size.

2 Film-to-subject distance

Focusing at macro scale is often tricky, because moving the lens changes not only focus but magnification, too. If you know exactly how big you want the image to be, it is simpler to calculate the necessary film-to-subject distance, then just move the lens until the picture is sharp. Here is the formula you need to use:

$$D = F \times (M+1)^2 / M$$

I want to dupe a 6x7cm transparency onto 35mm film. How far should the film plane be from the original transparency, using a 105mm macro lens? Magnification is $^{24}\!/_{60}$ or 0.4.

Keystroke	Parameter	Example
AC	Magnification	0.4
+	1	1
M+ × RM		
×	Focal length	105
÷	Magnification	0.4
=	Result	514.5mm

Exposure compensation

Focusing on nearby subjects progressively reduces the amount of light reaching the film, and when the subject distance is less than 10x the lens focal length, there is a significant effect on exposure. Through-the-lens metering takes care of the problem for you, but it is useful to be able to calculate the extra exposure, especially when you are using flash.

$$\text{Exposure compensation} = (M+1)^2$$

3 Exposure with symmetrical lenses

I am photographing a wrist-watch on a 5x4in camera. The watch face is 30mm in diameter and on the focusing screen it measures 65mm wide. A flash meter indicates f/32.

Keystroke	Parameter	Example
AC	Image size (mm)	65
÷	Subject size (mm)	30
+	1	1
M+ × RM =	Result	10.02777

So the necessary exposure increase is about 10x, or 3⅓ stops. Thus, I would need to open up the lens to about f/10 or give extra flashes.

Non-symmetrical lenses

This calculation works well enough for symmetrical lenses, but many lenses are either telephotos or retrofocus lenses. With these non-symmetrical lenses, the beam entering the lens (the entrance pupil) is a different size from the beam leaving the lens (the exit pupil). The ratio of entrance pupil diameter/exit pupil diameter is called the pupillary magnification factor (PMF or P). P is greater than 1 for telephoto lenses and less than one for retrofocus designs—most wide-angle and many standard lenses fall into the latter category.

You can measure P to a reasonable degree of accuracy using a clear plastic ruler. Place the lens on a light box, set any aperture smaller than the maximum and measure the diameter of the iris. The diameter as measured at the front is the entrance pupil diameter. At the back, you are measuring the exit pupil diameter. Divide the entrance pupil size by exit pupil size to get P. For example, my f/4 20mm Nikkor has an entrance pupil diameter of about 4mm when set to f/5.6, and an exit pupil diameter of 8mm at the same aperture. P is therefore 0.5.

In the exposure compensation formula above where (M+1) appears, substitute (M+P)/P. If the lens is reversed, where (M+1) appears, instead substitute (1/P)+M.

4 Exposure for non-symmetrical lenses

Using the 20mm lens mentioned above mounted on a bellows, I'm photographing a subject at double life size.

Keystroke	Parameter	Example
AC	Magnification	2
+	Pupillary Magnification factor	0.5
÷	Pupillary Magnification factor	0.5
M+ × RM =	Result	25

So I would need an exposure increase of 25x, or approximately 4⅔ stops.

In fact, because of its asymmetrical construction, such a lens delivers significantly improved results at macro scales when reversed, and it is a good choice because it is capable of delivering high magnification with little bellows extension.

5 Non-symmetrical lenses reversed

Using the same example, but with the lens mounted in reverse on the bellows:

Keystroke	Parameter	Example
AC	1	1
÷	Pupillary Magnification factor	0.5
+	Magnification	2
M+ × RM =	Result	16

I would therefore need to give only 3 stops extra exposure with the lens reversed.

6 Depth of field

At macro scale, depth of field is symmetrical about the plane of sharpest focus, and its extent is most accurately calculated from the magnification:

$$t = 2 \times c \times f \times (M+1)/M^2$$

For example, in the duping example given above, how much movement of the original transparency can be tolerated at an aperture of f/16? Magnification is 24/60 or 0.4.

Keystroke	Parameter	Example
AC	Magnification	0.4
M+ +	1	1
×	Aperture	16
×	Circle of confusion (mm)	0.036
×	2	2
÷ RM ÷ RM =	Result	10.08mm

So even if the transparency is quite badly buckled it will still stay sharp.

Supplementary close-up lenses

Close-up lenses don't give as good-quality images as a macro lens, but they are inexpensive, compact and require no extra exposure. The power of a close-up lens is generally expressed in dioptres: dioptre power is equal to one over the focal length in metres. Calculating the new point of sharpest focus when a supplementary is fitted is not difficult—simply use the formula below to work out the focal length of the combination of lenses, then use the formulas given on pages 60–3 to determine the subject distance for any particular lens extension you are using.

There is no keystroke guide here, because the calculation is rarely needed. When you fit all but the weakest close-up lenses, you'll find that the focusing action of the lens moves the point in sharp focus just a small distance. In practice, it is enough to know that, when the main lens is focused on infinity, the distance to the point in sharpest focus is equal to the focal length of the supplementary lens. So, for example, a +2 dioptre close-up lens has a focal length of $1/2$ metre, so the point in sharpest focus will be about 50cm (20in) away when the lens is focused on infinity. Note that this rule holds true regardless of the focal length of the prime lens in use.

Combined focal length = $(S \times F)/(S + F)$
where S is the focal length of the supplementary lens,
and F that of the main lens

Calculating magnification

The simplest way to determine the necessary extra exposure for a macro is to use magnification. This is easy using the table opposite: simply place a ruler or tape at the subject position, with one end visible in the viewfinder at the extreme edge of the frame. Check where the other side of the frame cuts the rule, then read off the magnification from the chart. With 5x4in film, place the rule parallel to the long dimension of the frame; with roll film, the rule crosses the film width. If you are using a symmetrical lens, you can also read off exposure compensation from the chart.

Bear in mind, though, that most viewing aids magnify and crop the image slightly, so if you judge magnification using this method, you may need to check whether your camera shows 100 percent of the image that will appear on film. You can do this by placing at the film plane a small piece of ground glass (or a plastic ruler) and comparing how much of the image is included at the film plane with the amount visible in the viewfinder. If you are using 35mm film, simply place the scale opposite close to the subject, so that it crosses the shorter dimension of the frame, and read off the magnification or exposure increase directly in the camera viewfinder.

Magnification and Exposure compensation for larger formats

Magnification	Exposure factor	Exposure increase (stops)	Ruler scale 6x6cm	Ruler scale 5x4in
5:1	36	5	11mm	2.5cm
4.5:1	30	5	13mm	2.8cm
4:1	25	4½	15mm	3.2cm
3.5:1	20	4⅓	17mm	3.6cm
3:1	16	4	19mm	4.2cm
2.5:1	12	3½	23mm	5.0cm
2:1	9	3	29mm	6.3cm
1.5:1	6.25	2	39mm	8.4cm
1:1	4	2	58mm	13 cm
1:1.25	3.24	1⅔	73mm	16 cm
1:1.5	2.77	1½	87mm	19 cm
1:1.75	2.46	1⅓	101mm	22 cm
1:2	2.25	1	116mm	25 cm
1:3	1.77	1	174mm	38 cm
1:4	1.56	⅔	232mm	50 cm
1:5	1.44	½	290mm	63 cm
1:6	1.36	½	348mm	76 cm
1:8	1.26	⅓	464mm	102 cm
1:10	1.21	⅓	580mm	127 cm
1:12	negligible		700mm	152 cm

Nomogram scales (right margin):

Exposure factor: 20 10 8 5 4 3 2·5 2 1·5 1·4

Exposure increase (stops): 4 3 2½ 2 1¾ 1½ 1⅓ 1 ⅔ ½

Magnification: 1:1 1:2 1:3 1:4 1:5 1:6

Shutter speed

The general rule on hand holding cameras is that the slowest safe speed is one over the focal length of the lens—so you can hand hold a 200mm lens at about 1/250. Shutter speeds for stopping movement are easily calculated. For example: what is the slowest shutter speed that will stop the motion of a car travelling at 30 mph (13.32 metres/second) 50m away, using a 28mm lens?

$$\text{Shutter speed} = F \times \text{subject speed}/[C \times (U-F)]$$

Keystroke	Parameter	Example
AC	Subject distance (mm)	50,000
−	Focal length (mm)	28
×	Circle of confusion (mm)	0.036
M+	1000	1000
×	Focal length	28
×	Subject speed (m/s)	13.32
÷ MR =	Result (fraction of a second)	207.316

So 1/250 will arrest the motion of the car.
For motion at 45° to the film, use one speed slower, and for approaching or receding subjects, two speeds slower.

Speeds of other subjects (m/s)

Walking	1.8	Tennis serve	67.0
Cars on superhighway	36.0	Marathon runner	4.5
Cars—urban traffic	14.0	100m sprinter	10.0
Formula 1 racing car	90.0	Express train	60.0
Bird in flight	18.0	Aircraft	75.0
Swimming	1.2	Light aircraft	35.0

Leaf shutters

When set to small apertures and high speeds, leaf shutters perform less effectively, leading to increased exposure and reduced action-stopping power. Here is the average error in stops:

Aperture	1/125	1/250	1/500
f/8	–	–	⅓
f/11	–	⅓	⅔
f/16	⅓	⅔	1 stop

Exposure

Introduction

Most modern cameras set exposure automatically, but there are times when it is useful to be able to estimate the correct exposure without referring to a meter. At night, for example, your camera's meter may not respond to low levels of light or it may give a misleading reading. Even in brightly lit conditions, an intuitive feeling for exposure ensures that you notice when your meter malfunctions.

Sources of exposure error

The commonest metering problem leading to incorrect exposure is "subject failure"—where the metered area is considerably darker or lighter than the scene as a whole. An incident light meter reading gets around this problem, but with a reflected light reading, experience and a working knowledge of the meter usually hold the key. Metering light reflected from a grey card (see below) eliminates subject failure, but an equally effective technique is to meter from the subject itself. You must then compensate by giving either increased or reduced exposure to take account of the non-standard subject reflectance.

Subject type	Adjust meter reading by
Sunlit snow, fresh white paintwork, clean white fabric	+2 stops
White sand, pale fabrics, weathered white paintwork, new plaster, pale grey sky	+1 stop
Weathered wood, light-coloured brickwork, green grass, dark grey or blue sky	No adjustment
Dark timber, freshly turned soil, autumn leaves, dark green foliage, blue sky deepened by polarizer	−1 stop
Dark coniferous woodland, dark suiting fabric	−2 stops
Matte black fabric	−3 stops

Other sources of error include:

Meter calibration The built-in meters found in the majority of modern cameras are calibrated to give good results with colour negative film, which benefits from a degree of overexposure. If you routinely use transparency film, this deliberate overexposure may produce unacceptable results. With any new camera, it is prudent to run an exposure test to calibrate the meter. Based on this, you may choose to set

an exposure index up to a stop faster than the film's nominal ISO rating.

Zoom lenses Many zoom lenses have variable apertures: the aperture is smaller at the longer focal length settings. Contrary to widely held opinion, the error occurs throughout the aperture range, not just at full aperture, and it can be as much as one stop. TTL meters take the change into account, but don't forget to make the necessary correction when using flash or a separate hand-held meter.

Bright colours The colour sensitivity of a camera's meter may not match that of the film, or of your eye. Brilliant colours are especially misleading, so if you are photographing these types of coloured subjects, use a grey card or incident light meter reading. When you are using brilliantly coloured filters, first take the meter reading without the filter and then apply the manufacturer's filter factor.

Memory effect Certain types of meter cell—notably cadmium sulphide—have a "memory" that can lead to errors of up to a stop. To avoid this problem, give this type of meter a minute or two to adjust to a dramatic drop in brightness levels. In the reverse situation, direct the meter at a subject about one stop brighter before taking a reading.

Tungsten light Note that film speeds for monochrome materials are quoted for daylight. Tungsten light has a lower actinic quality and film speed is therefore lower. With panchromatic film, divide your film speed by 1.5; ortho films need a stop extra exposure, and blue-sensitive films, two.

Fluorescent light Alternating current causes fluorescent lights to flash at a pace that matches mains frequency. The flickering is too fast for the eye to see but it can cause metering errors with some first-generation electronic cameras. With focal plane shutters, the flickering also causes unevenness of exposure, so always use shutter speeds of $1/30$ or slower when taking pictures by fluorescent light sources.

Exposure estimates

Bright sunlight is remarkably consistent in intensity at moderate latitudes, and you can use this fact to your advantage by estimating exposure using the "Sunny-16" rule. If you set the camera's aperture to f/16, the correct shutter speed is roughly equal to the film speed. As an example, if you are using ISO 400 film, you should set 1/400 at f/16—on most cameras 1/500 is the nearest equivalent.

This rule applies to front-lit subjects—for backlighting, give two stops additional exposure, and for sidelighting, one stop extra. Where surroundings are extremely bright, as on a beach of light sand or on snow, give one to two stops less exposure than the Sunny-16 rule indicates. In dimmer conditions, you will need to give extra exposure. In hazy sun, allow one extra stop; light cloud, two stops; and heavy overcast, three stops.

Bracketing and exposure latitude

Bracketing is an insurance policy that is familiar to most experienced photographers. However, bracketing intervals are most often dictated by habit, whereas they should ideally be matched to the film's exposure latitude and the lighting contrast. On a dull day with colour negative film, for example, bracketing at 1-stop intervals provides ample security. However sidelighting in sunny weather stretches the latitude of reversal film to the limit, and bracketing at ⅓-stop intervals is reasonable.

Grey card metering

If you don't have access to an incident light meter, a reflected light meter reading from the surface of an 18 percent grey card makes a good substitute. Kodak supplies a standard grey card, but there are numerous widely available alternatives. The subject matter marked "no adjustment" in the chart on page 67 also makes a good substitute for a standard card.

The reverse of the standard grey card reflects 90 percent of the incident light, and it therefore makes a useful highlight reference tone.

Problem exposures

Low light and extremely high-contrast subjects are notoriously difficult to meter, due to the fact that often the subject consists of brilliant highlights and pools of inpenetrable shadow. In these circumstances, exposure "guesses" ironically often produce better results than all but the most methodical metering. The two charts on pages 70 and 71 provide exposure information for difficult subjects.

In the left-hand column of the first table, you will find a range of different lighting conditions, and from these you can read off the correct exposure value for the film you are using. In the second chart, each diagonal bar represents a single exposure value, and by picking any point on the bar you can read up and across to find an appropriate shutter speed and aperture at the corresponding points on the horizontal and vertical axes.

For example, if you were photographing a floodlit sports event on ISO 800 film, the correct exposure value from chart 1 is 11. From chart 2, you will see that a range of shutter speeds and apertures give the correct exposure, from 1/1000 at f/1.4 to 1 second at f/64. Obviously you would choose a fast shutter speed in this situation, but in others, long exposures from the upper end of the tinted bar might be more appropriate: if, for example, you were photographing headlight trails from moving vehicles, you would clearly need to set an exposure of ten seconds or more. Note that the recommended exposures don't take account of reciprocity failure.

Subject matter	Film speed (ISO)				
	64–100	125–200	250–400	400–800	1000–1600
Cityscape at night	1	2	3	4	5
Cityscape immediately after sunset	10	11	12	13	14
Cityscape at twilight	8	9	10	11	12
Moving vehicles on busy roads	3	4	5	6	7
Buildings lit up by floodlights	4	5	6	7	8
Festive illuminations outdoors	7	8	9	10	11
Neon advertising signs	9	10	11	12	13
Bright city streets—general view	7	8	9	10	11
figure lit by street lights	4	5	6	7	8
Illuminated store window displays	8	9	10	11	12
Bonfires—general view	8	9	10	11	12
subjects lit by them	5	6	7	8	9
Firework displays—ground pieces	8	9	10	11	12
air bursts	9	10	11	12	13
Fairgrounds	6	7	8	9	10
Landscape by moonlight	–3	–2	–1	0	1
The moon itself—full	14	15	16	17	18
crescent	12	13	14	15	16
Partial eclipse of the sun, **using 5.0 ND filter**	13	14	15	16	17
Floodlit sports events at night	8	9	10	11	12
Circuses, theatre performances—					
general view	7	8	9	10	11
spotlit acts	9	10	11	12	13
School plays, amateur drama	5	6	7	8	9
Indoor sports—well lit	8	9	10	11	12
Swimming pools	6	7	8	9	10
Domestic interiors—general view	5	6	7	8	9
close to bright lights	6	7	8	9	10
candlelight	5	6	7	8	9
festive lights and Xmas trees	4	5	6	7	8
Hospitals—wards & maternity units	7	8	9	10	11
Churches & chapels—indoors by day	5	6	7	8	9
Public buildings and offices	8	9	10	11	12
Museums and galleries	5	6	7	8	9

Exposure values at ISO 100

f/	Shutter speed (1/secs)											Full seconds							
	2K	1K	500	250	125	60	30	15	8	4	2	1s	2s	4s	8s	15s	30s	1m	2m
64	23	22	21	20	19	18	17	16	15	14	13	12	11	10	9	8	7	6	5
45	22																		4
32	21																		3
22	20																		2
16	19																		1
11	18																		0
8	17																		-1
5.6	16																		-2
4	15																		-3
2.8	14																		-4
2	13																		-5
1.4	12	11	10	9	8	7	6	5	4	3	2	1	0	-1	-2	-3	-4	-5	-6
f/	2K	1K	500	250	125	60	30	15	8	4	2	1s	2s	4s	8s	15s	30s	1m	2m

Low light

Photography in low light presents special problems. The principal difficulty is the self-evident one of getting enough light onto the film, which is complicated by the fact that the film's sensitivity to light drops in dim conditions. This is the phenomenon known as reciprocity failure, or reciprocity law failure as it is sometimes called. Here is a pragmatic, practical guide—for a theoretical analysis, turn to virtually any serious photographic work on exposure.

The best way to cope with reciprocity failure is to avoid it. Sadly, this isn't always possible, because certain photographic applications actually demand long exposures. When using small apertures, you can sometimes avoid the problem by adding extra light, but to blur moving water, for example, you have no choice but to use an exposure of several seconds.

Every film responds differently when exposure times exceed one second. Column 5 of the tables on pages 8–14 gives a concise summary of the correction required, but bear in mind that these figures are only the average of several batches of film and there may be wide batch-to-batch variations. To be sure that your pictures won't develop a colour cast, run the tests outlines on page 23.

Reciprocity failure affects contrast as well as colour: in a scene that has a wide range of brightness levels, contrast increases still further at long exposure times. With monochrome film, you can compensate by cutting develop-

ment; with colour, however, there is no such easy solution. Another aspect of the same problem is that when combining flash and (dim) available light, you must remember to compensate for reciprocity failure only when calculating exposure for those areas that are not lit by flash.

Data for the correction of reciprocity failure has two components—exposure and filtration. With colour film, it is safest to give the extra exposure by opening up the lens aperture. Leaving the shutter open longer has a less predictable effect, because the intensity of the light striking the film is unchanged. With monochrome you have more choice (see below). The exposure-compensation figure supplied always takes account of the density of any corrective filtration—don't allow additional exposure because of the filters.

The characteristics of each emulsion layer put an upper time limit on the degree of compensation for reciprocity failure. If you are forced to cross the barrier into the "Not Recommended" region of a film manufacturer's data, your pictures will probably shows signs of crossed characteristic curves. This means that shadows and highlights develop casts of different colours, with the result that no filtration will produce a satisfactory image.

If you regularly use automatic exposure control in dim light, bear in mind that exposure meters do not take account of film's reciprocity failure characteristics. This makes automatic exposure at shutter speeds longer than a second effectively useless.

Unknown emulsions Filtration and exposure compensations vary so widely between films that no general guidelines about corrections will be satisfactory in every case. However, averaging figures for exposure compensation produces this result:

Film type	1 second	10 seconds	100 seconds
Colour negative	+1 stop	+2 stops	+2½ stops
Colour reversal	+½ stop	+1½ stop	+2½ stops

If you can't locate up-to-date information about the film you are using, apply these corrections and bracket a stop either side to be safe.

Monochrome films Black and white film has such wide exposure latitude that reciprocity failure is less often a problem. However, when exposures exceed a second you should use the following corrections.

Indicated exposure	Use instead	Or open aperture	Cut development
1 sec	2 sec	1 stop	10%
10 sec	1 min	2 stops	20%
100 sec	20 min	3 stops	30%

Tungsten-balanced films In dim conditions, films balanced for tungsten light are generally a better choice than daylight-balanced emulsions. For this reason, if you frequently use long exposures in daylight illumination you may prefer to load a tungsten film into the camera and correct colour with an 80A filter.

Too dim to meter?

If you have difficulty getting a meter reading from the subject itself in dim light, try instead taking a reflected light reading from a white card—then give two stops extra exposure. If even this doesn't work, point a reflected light meter toward the light source, take a reading and then open up five stops.

Bright lights

Film loses its speed at very short exposures, too. However, there are just two common situations where high-intensity reciprocity failure is likely to be noticeable. One is when you are using an electronic flashgun that delivers exposures shorter than 1/5000 at close subject distances. This may sometimes cause underexposure and a slight blue cast to be noticeable. The solution here is to use a CC05 or 10 yellow filter. High-intensity reciprocity failure also causes trouble when you are using tungsten films with fast shutter speeds or flash. Reciprocity failure may set in at speeds as slow as 1/60. Manufacturers don't supply filter and exposure recommendations for such eventualities, but the problem is generally easy to avoid in the majority of situations.

Judging exposure in dim light

With experience you can use the threshold of vision to determine exposure. The technique works best with view cameras, but you could adapt it for smaller format cameras, too, provided that you exclude all extraneous light. To do this put your head under the focusing cloth and allow two or three minutes for your eyes to accommodate the light levels. Then gradually stop down the lens and judge the smallest aperture at which you can still see shadow detail.

Smallest aperture at which shadow detail is seen	f/8	f/11	f/16	f/22	f/32	f/45	f/64
Exposure time at f/11 (ISO 100, secs)	64	32	16	8	4	2	1

This works only in dim lighting conditions; in sunlight it is possible to see some detail in even the deepest shadow areas of your subject.

The sun and moon

To obtain a good-sized image of the sun or moon on film you need to use a very long-focus lens. A good guide to scale is that the image of the sun or moon is 1mm wide for each 110mm of the focal length of the camera lens. So to get a disc 1cm across (less than $1/2$in) you'll need a 1100mm lens. Fortunately, few of us require details in images of the moon and the cheapest of teleconverters yields adequate results.

However, with the equivalent of a 1000mm lens on the camera the sun and moon create extremes of contrast that no film can cope with. If you just want figures silhouetted against the sun or moon, there is no problem, but for other purposes you may wish to use the double-exposure methods described below.

Photographing the sun

Use common sense when photographing the sun. If it is uncomfortable to look directly at the sun with the naked eye, don't look at it through the viewfinder of the camera.

Exposure for sunsets varies widely and it is best to use a TTL or selective-area meter, and then apply the usual rules about metering for *contre-jour* lighting. For maximum colour at the expense of foreground detail, meter for the sun itself; for a slightly more realistic impression, meter from the sky adjacent to the sun but exclude the sun's disc from the area of maximum meter sensitivity.

Eclipse photography

Photographing a solar eclipse is especially risky, because the sun is often high in the sky and therefore extremely bright. If possible, fit a neutral density filter with a density of 5: this cuts the sun's brightness by a factor of 100,000. A cheaper substitute is thin aluminized mylar film.

If the eclipse is total, exposures vary dramatically, and during the period of totality no filter is needed. Take care, though, as immediately after totality the brightness abruptly rises again.

Photographing the moon

Photographing the moon presents no risks, but its progress across the sky follows complex rules.

- The moon always rises later today than yesterday, and appears at twilight only when it is approaching an eclipse with the sun—this happens about twice a year.
- The harvest or hunter's moon rises after twilight, but does so a little later each night.
- The harvest moon is around August or September in the northern hemisphere.

For general photography, the moon is at its most attractive when it's only a little brighter than the sky. When the sky

darkens, the moon appears as a flat white disk. There is a greater variation in sky brightness the farther north you go, so good moon pictures are easier to take in the higher latitudes.

Movement
The earth's motion causes the moon and sun to appear to move steadily across the sky at a predictable rate. As a guide, each moves through its own diameter in about 2 minutes. If you are using a telephoto lens longer than about 400mm, this movement seems surprisingly fast and you will need to reposition the tripod constantly to maintain the same composition. When photographing the moon, the movement causes blurring elongation of the moon's disc at long exposures: even on the steadiest tripod, you should restrict shutter speed to 10 seconds with a standard lens and use proportionately faster shutter speeds with longer focal lengths.

Double exposures If your camera has a double-exposure mechanism, you have a very quick way to add the sun or moon to any scene. First, photograph the sun or moon using a long focal length lens to obtain a large image on film. Next, tension the shutter without advancing the film and turn the camera to compose another scene—but remember to leave space for the image of the moon or sun in the scene.

The only possible pitfall when you are using this technique is that the combined image will look unnatural. If the setting sun appears in the picture, it is natural to expect other subjects to be backlit—and they won't be if you turn the camera between exposures. A more obtrusive problem is perspective. In pictures shot with a wide-angle lens, a large sun or moon appears very odd. So for the second exposure, it is best to use a standard lens or one of a longer focal length.

Adding the sun or moon to another unconnected image is a simple matter if you have access to a darkroom or a slide duplicator. The necessary techniques are quite standard and need no elaboration here. The advantages are threefold. First, your choice of subject matter is unlimited: you can build up a library of sun and moon images and combine them with virtually any other picture. Second, you can enlarge the sun or moon to any size you require without the expense of a long lens. And, finally, you can combine images both additively and subtractively—sandwiching slides together allows you to superimpose dark figures against the sun and double exposure lets you drop the moon into a dark sky.

When setting your controls for both sun and moon images, use the master chart on page 70. However, bear in mind that the moon's phase and the weather greatly affect exposure.

TV, video and computer screens

The principal problem in photographing any video display is that the image is renewed line by line, which means that if you use fast shutter speeds you will record only a portion of the picture. The scan rate determines the fastest practical shutter speed, and this varies according to the TV standard in use. Most European countries use either PAL or SECAM, which both have scan rates of 50 cycles. In the USA and Japan, however, the TV system is NTSC, which has a slightly higher scan rate of 60 cycles. For other countries, consult the travel table on pages 106–112.

Each system takes two scans to build up a whole picture, so the fastest shutter speeds you can use are 1/25 for PAL and SECAM, and 1/30 for NTSC. Faster speeds leave a dark bar across the screen and with slower speeds there is the risk of image movement spoiling the picture. The situation is complicated in Europe by the fact that few shutters have a speed of 1/25, and in America by the risk of the shutter running slightly fast and thus creating a dark bar. A handful of cameras have a "TV" exposure mode that is set to match exactly the TV scan rate. With other models it is best to use a speed of 1/15 to be sure of photographing a full picture.

If you want just the TV screen in the picture, darken the room, and check for extraneous reflections with the TV switched off. Switch on, tune in the best picture possible and then reduce the contrast slightly. TTL meters usually give a correct indication of exposure. For optimum colour results shoot a test roll, and mark or tape the TV control positions. NTSC sets have a hue control to allow you to adjust colour, but with PAL and SECAM the hues are fixed on broadcast, so you can fine tune hue only with filters.

If you need to include the TV in a wider picture, you should ideally make two exposures on a single frame: the first one records the screen in a darkened room; in the second, light the room and cover the screen in black cloth. As a precaution, before striking the set or leaving the location, it is wise to take these two shots on separate pieces of film, but this time, for the second, uncover the TV set and switch it off so that the edges of the tube pick up reflections of the room lighting. If all else fails, a retoucher can then combine the two images.

If you haven't time for all this, adjust room lighting to give a shutter speed of 1/15 and adjust the TV brightness to match the room. A video cassette recorder with a still-frame facility makes it easier for you to catch a particular image off the TV, but it may create noise bars.

To photograph computer screen images, follow the same rules, but because the picture is generally static, you can set a slower shutter speed—1/4 is a good choice. With liquid crystal displays you will obtain the best screen results by using a hard light source, such as a spotlight.

Remember that copyright exists on most TV images.

Pinhole photography

The value of using the pinhole camera in serious photography is that the resulting images have infinite depth of field and they are absolutely rectilinear. On the minus side, pinholes suffer badly from chromatic aberration—15 times worse than a simple lens. With care, pinhole cameras can produce quite sharp images and they are especially useful when a very broad field of view is required—you simply build a wider box. For the best results, create the largest image possible, because pinhole negatives don't tolerate much enlargement.

The best material in which to make the hole is brass shim 0.05mm (0.002in) thick, but the aluminium foil used for take-away food containers is easier to find. To make the hole, rest the metal on a piece of cardboard and press gently down with a needle, rotating the needle constantly. Periodically, turn the metal over and sand down the top of the resulting dimple with very fine emery paper. Repeat this process until a hole appears. The hole should be perfectly round, without ragged edges, so you will need to check it with a magnifier. Perfectionists who wish to buy ready-made pinholes in precise sizes should consult an optical component supplier, where they are sold to holographers for use as spatial filters.

Hole sizes How big should the hole be? This depends on the size of the camera you use. Where F = film-to-hole distance and d = hole diameter, $F/k = d^2$. The factor k is a constant of around 1300. In practical terms, hole sizes are dictated by needle sizes: sewing shops sell needles to size 9, but you can buy sizes as small as 12 for threading beads.

Needle number	Diameter (mm)	(in)	Box length (cm)	(in)	Aperture (f/)
4	0.91	0.036	100	40	1120
5	0.79	0.031	75	30	960
6	0.74	0.029	65	27	930
7	0.66	0.026	55	21	800
8	0.58	0.023	42	16	690
9	0.50	0.020	32	13	650
10	0.46	0.018	26	10	550
12	0.40	0.016	21	8	500
13	0.33	0.013	13	5	380

Exposure You can assign an f-stop to a pinhole camera by dividing the pinhole-to-film distance by the hole diameter. If you are exposing onto film, determine exposure in the usual way. But for enlarging paper, a speed of ISO 4 is a good starting point. You may have to create a new scale for any light meter you use, since few mark apertures of f/1000.

Lighting

Calculating light

Even the briefest explanation of photometry requires a considerable amount of space, but the following information may sometimes prove useful.

The inverse square law

Valuable in day-to-day photography are the laws governing changing light intensity, especially the inverse square law. This states simply that the intensity of the light falling on a subject is inversely proportional to the square of the distance between subject and lamp. In other words, if you double the distance you reduce brightness to a quarter; treble the distance, and brightness falls to 1/9. Increase the distance by the square root of two (or about 1.4) and the brightness is halved.

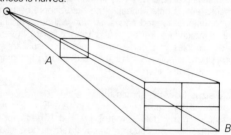

If you double the distance of an object from a light source (from A to B) the light illuminates four times the area and is only a quarter as bright.

The greatest value of the inverse square law is in positioning lights. For example, to make a series of test exposures for duplicating transparencies you might multiply the distance between the flash and slide by the square root of 2 in order to reduce exposure by 1 stop. A sequence of exposures reducing by 1-stop intervals would thus run 1m (or foot, or yard), 1.4, 2, 2.8, 4, 5.6 and so on.

Bear in mind that the inverse square law works only for point sources of light, in the absence of reflecting surfaces. Light from larger sources, such as windows, falls off very much more slowly.

The cos law

This is another useful relationship. When light strikes a surface obliquely, its brightness is diminished by the cosine of the angle at which it strikes (angle A in the diagram above). For example, the cosine of 60 degrees is 0.5, so light striking a surface at 60 degrees halves in brightness.

Flash photography

Electronic flash is a uniquely photographic light source. However, even some otherwise competent professional photographers are intimidated by the fact that flash is instantaneous and shy away from using it under any but the most controlled conditions.

The power output of a flash unit is measured in a number of different ways. The commonest is the guide number, or GN, which is the subject distance multiplied by the f-number that produces correct exposure. However, power is also specified in the form of watt-seconds (which are numerically equal to joules) and beam candle-power seconds or BCPS. Joules and w/s are a good guide to the brute power of a flash, but they do not take into account the efficiency of the reflector. BCPS does take this into account, and you can convert BCPS roughly into GNs as follows:

$$\text{GN (in feet)}^2 = \text{BCPS} \times \text{ASA} /20$$

Guide numbers are always specified for a particular film speed either in metres or feet—so never mix metric and imperial units. To convert a guide number for use with a different film speed:

$$\text{New GN} = \text{Old GN} \times \sqrt{(\text{new ISO/old ISO})}$$

Doubling film speed thus increases the GN by a factor of about 1.4; quadrupling film speed multiplies it by 2.

Manual flash

Automatic flash units may be convenient but they are easily misled by dark or light subjects, leading to over- or underexposure respectively. If you have an accurate guide number for your flash, calculating the f-number from the guide number eliminates the problem of subject reflectance. This can be a once-only task if you regularly use just one speed of film and one flash unit: mark the correct apertures on the lens focusing scale.

Mark standard apertures for flash on focusing scale.

Bounce flash

With transparency film, estimating exposure for bounce flash is a risky business because the reflectance of an apparently white ceiling or wall can vary widely, and the film's limited exposure latitude is not forgiving of exposure errors. However, you can estimate the required exposure as follows:

1 Figure the *total* distance the light travels—from the flash to the ceiling to the subject.
2 Divide this into the guide number to get the basic aperture.
3 Open up one stop to compensate for the light lost on reflection.

Total distance is flash to ceiling plus ceiling to subject.

In large or dark rooms you may need to give additional exposure. Take a close look at the surface from which you plan to bounce light and compare its colour with that of a sheet of white paper. No thinking photographer would bounce light from a brightly coloured wall, but tints pale enough to pass unnoticed on the ceiling can nevertheless create objectionable colour casts on film. Even pure white paintwork yellows with age, but the colour shift is usually slight and, if anything, beneficial, adding a little warmth to flesh tones.

Fill-in flash

This valuable technique is easy to perfect if you have access to an instant-film test or flash meter, but these handy tools don't really lend themselves to rapid working. Here are two alternative ways to determine the correct exposure for fill-in flash that don't require either a meter or a Polaroid back.

Manual flash unit

1 From the guide number of the flash, determine the correct aperture for the subject distance you are using, assuming that the flash is the only light source.
2 Set this aperture on the lens.
3 Meter the ambient light to determine the correct shutter speed. If this is faster than the top synchronization speed, move closer and start again, as above.
4 Move the flash away from the subject—for a 2:1 ratio of daylight to flash, the flash unit should be about 1½ × the camera-to-subject distance. For a 4:1 ratio, the flash should be twice as far from the subject as it is to the camera.

This method works particularly well with zoom lenses, because you can leave the flash on the camera, move back to the appropriate distance and then zoom in to frame the subject once more.

Auto flash unit

1 On the flash calculator dial, set a higher film speed than the nominal ISO rating of the film you are using. For a 2:1 ratio, set 1 stop faster; for a 4:1 ratio, set 2 stops faster.
2 Choose the smallest aperture option available and set this on the lens.
3 Meter in the normal way to determine the correct shutter speed.

If you are using fast film or a weak flash unit, this method may force you to use a shutter speed faster than the camera's maximum flash synchronization speed. If so, switch to manual and use the method outlined above; otherwise, use a camera with a higher synch speed or a more powerful flash.

Multiple flash

The safest way to trigger dissimilar multiple flash units is to synch one from the camera, and fire the others using slave units. Running several units from a "Y" adapter is safe only if all the flash guns have the same polarity. If they have different polarities (there is a 50:50 chance that they do) there may be damage to one or both flash units.

If you use two identical flash units, their combined guide number is 1.4x the individual GN. For 3 units, multiply by 1.7, and for 4, by 2. For larger numbers, use the multi-flash rules below.

Firing a single flash repeatedly is a useful way to get smaller apertures at no extra cost—provided the subject is static. Take care, though, to ensure that insignificant ambient light reaches the subject while the shutter is open, or unwanted shadows or a colour cast may result—particularly if tungsten light is nearby.

Number of flashes needed = (GN required/GN of flash)2

Keystroke	Parameter	Example
AC	Required GN	160
÷	GN of flash unit	60
M+ × MR =	Result	7.1111107

So seven flashes give the correct exposure. This calculation works equally well for setting the correct apertures—simply substitute f-number for guide number.

Light trails

Combining ambient light and flash can create an attractive juxtaposition of flowing light-trails with a sharply recorded subject, but for a natural-looking image, the subject must move backward, not forward. A little thought reveals the reason for this: the overwhelming majority of cameras trigger the flash the instant the shutter is fully open. So a forward-moving subject, such as a car, will produce trails that "lead" the image frozen by flash. The car must move backward to produce following trails. A few cameras now have "second-blind synchronization", which fires the flash just before the end of the exposure, thus eliminating the problem. Improvisation, mechanical or electronic, can also achieve this feat with little difficulty (*Modern Photography*, September 1987, provided full details).

Tinting the background with flash

By fitting a brilliantly coloured filter over the camera lens and a filter in a complementary colour over the flash, you will tint the background the colour of the filter on the lens, while recording the foreground in its natural hues. However, the light absorbed by using these two filters in conjunction is considerable and the technique is really only practicable if you are using a powerful flash unit over relatively short subject distances.

Slaves and synchronization

The common-or-garden slave trigger does not function reliably in brilliant sunlight: its range is reduced, and the flash is frequently triggered by moving the slave suddenly from shadow into sunlight. However, you can double or even quadruple the effective distance at which the slave will operate simply by constructing a black hood to shield the light-sensitive cell from the bright ambient light. An old 35mm film container makes a fine and readily available shield. Bear in mind, however, that masking the cell in this way makes the cell more directional, so take care to align the flash and slave carefully.

Shield a slave's light-sensitive cell in bright sunshine.

Expendable flashbulbs

Expendable flashbulbs pack a lot of power into a very small space and they require inexpensive firing equipment. They are, therefore, a sensible choice for very large subjects that would be difficult to light with tungsten or electronic flash. Unfortunately, most manufacturers now make flashbulbs only for the cheaper snapshot cameras: the larger bulbs that are so valuable to the professional are relatively hard to get hold of.

To those photographers who have grown up with electronic flash, expendable bulbs take some getting used to. Bulbs take a while to reach peak power output—typically 1/50 to 1/100; and they burn for about the same time again. Unless your camera has "M" class synchronization, you will need to use a shutter speed slower than 1/30 to utilize the full power of the bulb. This restriction more or less limits the use of flashbulbs to interiors and to the hours of darkness, when ambient light cannot form secondary ghost images.

Exposure for expendable flashbulbs depends on the shape, size and degree of polish of the reflector, but as a starting point for exposure tests try these guide numbers:

Bulb type	GN (meters, ISO 100)
AG–3B and PF3B	40
Type 2	140
Type 2B	105

If a single bulb doesn't provide enough power, try taping two together: the heat of the first bulb igniting will trigger the second.

You can use faster shutter speeds with M synchronization, but at the expense of some of the bulb's light output. This chart indicates very approximately how much extra exposure in stops is needed when using M synchronization:

$\frac{1}{15}$	$\frac{1}{30}$	$\frac{1}{60}$	$\frac{1}{125}$	$\frac{1}{250}$	$\frac{1}{500}$
+0	+$\frac{2}{3}$	+1	+2	+2	+3

Judging exposure with pilot lights
No. 2 flashbulbs fit into standard ES holders and you can judge exposure by replacing the flashbulbs with 500W photofloods. If you then take a meter reading, the correct aperture will be alongside the 4-second mark for clear bulbs, and the 2-second mark for blue bulbs.

Firing circuitry
Though ready-made units are available, flashbulb triggers are not difficult to build. This circuit diagram permits multiple flash, as well as continuity testing without firing the bulbs:

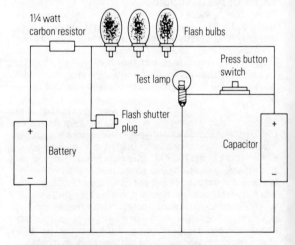

Number of bulbs	Capacitor mfd	volts	Battery volts	Resistor K ohms	Test lamp V	A
1–6	250	25	22.5	3	6	0.04
7–12	500	45	45	5	12	0.2
13–18	750	70	67.5	10	12	0.1

Sockets not in use must be shorted for the circuit to work.

Flash powder

This archaic light source is enjoying something of a revival. Like expendable flashbulbs, its principal advantage is high power at low cost and weight. The drawbacks should be fairly obvious—it is undoubtedly dangerous if used incorrectly (please read the disclaimer on page 4) and it does not work when wet. But then, the same could be said of an electronic flash unit.

While it is possible to mix your own flash powder (see page 138), it is probably safer to buy supplies from theatrical stage effects suppliers. Such sources also sell the vital blue touch paper, though theoretically at least, the enterprising could rig up a synchronized electronic circuit to fire the powder instead.

As a starting point for exposure, use an aperture of f/11 with ISO 100 film and the following quantities:

6ft	12ft	24ft	36ft
1g	2.5g	7g	12g

Note: there are 28g to the oz.

Spread larger charges of powder in a line and ignite it in the middle.

The powder produces a flash with colour temperature of around 4300K: small quantities produce a warmer colour, and larger heaps, a colour that approximates more closely to daylight. However, since the powder is rarely used for a completely natural effect, filtration is not generally needed.

Because of the uncertainty concerning exposure, it is wise to use colour negative film. For crucial shots with transparency material, you could try setting up two cameras—processing film from the first will indicate whether the second film needs pushing or pulling.

Red eye

This well-known problem is caused by flash light passing through a subject's dilated pupil and illuminating the retina. Red eye crops up most frequently in very dim conditions when the lens and flash are close together *relative to the subject distance*. Unless you use a small shoe-mounted flash, you are likely to encounter this problem only when using flash for distant subjects. The solution is simple—shine a bright torch in your subject's eyes to make the pupils contract, or increase the distance between the lens and flash.

Testing an electronic flash unit

Most of the functions of an electronic flash unit can be tested simply using a flash meter: if you don't have access to one, you can carry out the tests below by making a series of exposures and then comparing the results with flash unit specifications.

Before starting, make sure the batteries you are using are at room temperature—low temperature reduces the capabilities of any cell. And don't start the evaluation before you have formed the capacitors by pressing the open flash button several times. (The procedures for forming the capacitors may vary in detail from model to model, so read the instructions that accompany your flash unit.) Carry out these tests in a light-painted, moderately small room—these are the conditions under which guide numbers are measured by the manufacturers, so you need to reproduce them as closely as is possible.

Guide number on manual Use the flash meter or a test exposure to check that the guide number or exposure calculator dial correctly reflects the power of the unit when it is set to manual.

Recycling time Fire the flash with it switched to full power and then check the amount of time that elapses until the ready-light comes on, once more indicating that the flash is ready to fire once more.

Hot spot Fit the flash to a camera and look through the viewfinder using the lens with the widest angle of view that the flash unit covers. Note where the edges of the frame fall and then take flash meter readings at the centre and edges of the field of view. There should be less than a 1-stop difference between the readings. Alternatively, photograph a white wall. Remember that many wide-angle lenses have a slight hot spot and this will aggravate the problem if the flash also illuminates the centre of the frame more brightly than it does the corners.

Ready-light Take a picture or a meter reading with the flash set to manual as soon as the ready-light comes on, and another reading or picture a minute later. This tests how well the capacitor is charged when the ready-light comes on. Often the ready-light indicates that only approximately 70–80 percent of full flash power is available, and not the full power you would expect. This can have a significant effect on exposure.

Exposure consistency With automatic flash units, make a series of test exposures or take meter readings at the closest and farthest distances specified in the automatic range, and another at one intermediate distance. (Bear in mind the previous test and allow a full minute between flashes.) Make sure that the sensor of the flash unit "sees" a neutral grey subject throughout the range—ideally hold up a large piece of grey board as a target for the flash sensor to read from.

Dedicated functions Finally, check the various dedicated functions available on the flash unit. For example, check that the "idiot-light" does, in fact, indicate correct exposure, and verify that the ready-light appears in the camera viewfinder if this is one of the features. Check the user manual accompanying your flash if you are in doubt.

Introduction

Most colour film is manufactured to give its best results when exposed using the hypothetical "Photographic Daylight" as a light source. Photographic daylight is a mixture of direct sun and open blue sky illumination as found at Washington DC in the USA on a typical clear day between the hours of 10 am and 4 pm. This leaves photographers in other countries with a problem.

Filtration provides the solution, but picking the right filter for any given lighting condition is no easy task. The problem is compounded by the fact that photographers generally specify light source colour and film sensitivity using a particularly unwieldy scale.

Colour temperature and the kelvin scale

All hot light sources glow with a colour that is closely related to their temperature. Heated to 1000°C, an iron bar glows with the same shade of orange-red anywhere in the world. This provides the basis for the method of measuring the colour of light that we call "colour temperature".

The colour temperature scale, though, continues from red and orange through white to include blue colours that could not in reality be produced by heating metal. Also, colour temperatures are measured in kelvins. This is a scale that is equal to 273 + the temperature in Celsius to which a black object would need to be heated to reproduce the colour of the light under consideration.

The chart on page 90 shows the colour temperature of some of the most common light sources.

Filtration and mireds

As a way of specifying colour the kelvin scale works fine. However, when it comes to selecting a filter, the system proves cumbersome. This is because filters don't shift the colour of light by a fixed number of kelvins. For example, the familiar Kodak Wratten 81B filter reduces the colour temperature of daylight by 715 kelvins, but lowers the colour temperature of tungsten light by only 65 kelvins.

You can solve this problem, however, by dividing the kelvin rating of a light source into a million to produce its mired value. Similarly, dividing mireds into a million converts back to kelvin. Mired is pronounced "my-red" and it is an abbreviation for MIcro REciprocal Degrees. The mired scale runs the opposite way to colour temperature: reddish light sources that have a low colour temperature have a high mired value; bluish light sources, conversely, have a low mired value.

Just as light sources can be assigned fixed mired

values, so too can filters. Bluish filters have a negative mired value and thus shift the colour of a light source to a lower mired value. Reddish filters have positive values and thus shift colour higher up the mired scale.

Blue filters have negative mired values, red filters positive mired values

Mired value of light source + mired shift of filter = new mired value

Filter systems

The most widely used filters for still photography are Kodak's Wratten series, and filters from other manufacturers are often specified as "equivalent to Wratten xxx". Kodak divides its filters for colour temperature adjustment into two groups. The first are conversion filters, which you use to make gross changes to colour balance so that, for example, you can use a tungsten-balanced film in daylight. The second group consists of light-balancing filters, which you use to make smaller changes.

Yellowest																		Bluest
85B	85	85C	81EF	81D	81C	81B	81	neutral	82	82A	82B	82C	80D	80C	80B	80A		

The drawback to using Wratten filters—especially in conjunction with a colour temperature meter—is that they have awkward mired values, such as −111 or +42.

Mired filters get around this problem. They are generally manufactured with values of plus and minus 15, 30, 60 and 120 mireds and you can, of course, combine them to produce intermediate values. Strengths are frequently specified in decamireds: 1 decamired = 10 mireds.

Borrowing from the movie industry

In the film industry, the colour of daylight is frequently controlled by filters over light sources and windows, and here yet another standard coexists with Kodak's Wratten filters. Colour temperature orange filters are used to reduce the colour temperature of daylight to match it to the tungsten-balanced movie stock. Filters with fractional values give partial correction (see chart opposite). Similarly, a full colour temperature blue filter raises the colour temperature of a tungsten lamp to match that of daylight, and booster blue filters with fractional values compensate for fluctuations in lamp voltage or aging lamps. Filter designations may vary slightly from one manufacturer to another.

Some of the other filters from movie-oriented manufacturers are of limited use in still photography. Both Lee and Rosco manufacture a useful range of sheet filters that combine colour conversion with a neutral-density element. In still photography, these filters are valuable for covering windows when using tungsten light to provide

fill-in interior shots. For example, the Rosco 85N6 filter balances the colour of daylight to match the sensitivity of tungsten-balanced (type B) film, and additionally absorbs two stops of the light from the window, thereby greatly reducing the amount of fill light needed. The neutral-density element is also available without the shift in colour temperature.

Other light-balancing products include diffusion media and blue filters that both diffuse tungsten light and change its colour temperature to match the colour sensitivity of daylight film.

Mired values and filter factors for common filters

Filter	Mired shift	Filter factor (stops)
Wratten		
85B	+131	2/3
85	+112	2/3
85C	+81	2/3
81EF	+52	2/3
81D	+42	2/3
81C	+35	1/3
81B	+27	1/3
81A	+18	1/3
81	+9	1/3
82	−10	1/3
82A	−21	1/3
82B	−32	2/3
82C	−45	2/3
80D	−56	2/3
80C	−81	1
80B	−112	1 2/3
80A	−131	2
Decamired		
+1.5	+15	1/3
+3	+30	1/3
+6	+60	2/3
+12	+120	2/3
−1.5	−15	1/3
−3	−30	1/3
−6	−60	2/3
−12	−120	2
Movie industry		
Rosco Colour temp. orange	+167	1
Lee CTO (Rosco 85)	+131	1
Half CTO	+81	1/2
Quarter CTO	+42	1/3
Full blue	−131	1 1/2
Half blue	−68	1
Third blue	−49	2/3
Quarter blue	−30	1/2
Eighth blue	−12	1/3

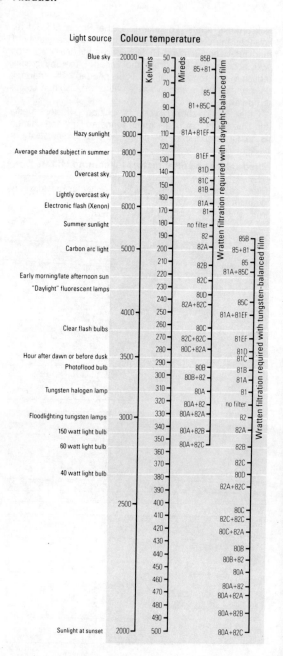

Light source	Colour temperature					
	Kelvins	Mireds	Wratten filtration required with daylight-balanced film		Wratten filtration required with tungsten-balanced film	
Blue sky	20000	50	85B			
		60	85+81			
		70				
		80	85			
		90	81+85C			
	10000	100	85C			
Hazy sunlight	9000	110	81A+81EF			
		120				
Average shaded subject in summer	8000	130	81EF			
Overcast sky	7000	140	81D			
		150	81C			
		160	81B			
Lightly overcast sky			81A			
Electronic flash (Xenon)	6000	170	81			
Summer sunlight		180	no filter			
		190	82		85B	
Carbon arc light	5000	200	82A		85+81	
		210			85	
		220	82B		81A+85C	
Early morning/late afternoon sun			82C			
"Daylight" fluorescent lamps		230				
		240	80D			
			82A+82C		85C	
	4000	250			81A+81EF	
		260	80C			
Clear flash bulbs		270	82C+82C		81EF	
		280	80C+82A		81D	
Hour after dawn or before dusk	3500				81C	
Photoflood bulb		290	80B		81B	
		300	80B+82		81A	
Tungsten halogen lamp		310	80A		81	
		320	80A+82		no filter	
Floodlighting tungsten lamps	3000	330	80A+82A		82	
150 watt light bulb		340	80A+82B		82A	
60 watt light bulb		350	80A+82C		82B	
		360				
40 watt light bulb		370			82C	
		380			80D	
		390			82A+82C	
	2500	400				
		410			80C	
		420			82C+82C	
		430			80C+82A	
		440			80B	
		450			80B+82	
		460			80A	
		470			80A+82	
		480			80A+82A	
		490			80A+82B	
Sunlight at sunset	2000	500			80A+82C	

Film colour balance

Daylight-balanced colour transparency films are manufactured to give optimum results in light with a colour temperature of 5500K (182 mireds). With one exception, tungsten-balanced transparency film gives optimum colour in 3200K (313 mireds) light. The exception is Kodachrome 40, which is balanced for 3400K (294 mireds).

Colour negative films have more leeway for correction of errors in the darkroom, and a few amateur emulsions are sensitized so as to give acceptable colour without filtration under any lighting conditions.

Fluorescent light

Fluorescent tubes present the photographer with a special challenge. Unlike "hot" light sources, a strip lamp produces light that doesn't fit neatly on the colour temperature scale, and so you can't use the familiar blue and yellow 80, 81, 82 and 85 series filters. Instead, fluorescent tubes need colour compensating filters—usually yellow and magenta—in a range of strengths.

Rule of thumb

If you're not sure which tubes you are dealing with, use 30 magenta filtration with daylight-balanced film, or 50 red with tungsten-balanced film (type B).

Matching tube and filter

If you can identify the tubes in use, you will be able to adjust filtration with more precision. Use the guidelines in the chart below as a starting point—but carry out exposure tests or use a three-cell colour temperature meter when colour rendering is critical.

A few filter manufacturers produce "fluorescent" camera filters that correct either daylight or tungsten film for use in fluorescent light. However, there is no accepted standard for the colour of these filters and in some circumstances the filter will produce little noticeable improvement.

Filtering light sources

If you are in total control of the photographic location, you are not limited to the use of filters on the camera lens alone, and filtering the light sources may be the best way to eliminate the colour cast that fluorescent tubes often create. Indeed, this may be the only option in circumstances where there is a mixture of light sources.

Filtering fluorescents

Companies supplying filtration media to the film industry make amber and magenta sleeves that slide over fluorescent tubes, and correct the colours of the tubes to match

the sensitivity of tungsten- and daylight-balanced films. This same material is also available in sheet form.

However, these sleeves are matched to the phosphors of US tubes—some small additional correction may be needed in the UK and elsewhere.

Filtering other light sources

If a scene is lit by a mixture of fluorescent and other lights, a better approach may be to leave the tubes unfiltered and place gels over the other lamps. For example, you may wish to put green gels on windows to balance the colour of daylight with that of the fluorescents; a magenta filter over the camera lens then corrects the hue of both fluorescents and windows. If you are using flash, this technique is very economical, since you can use small pieces of filter gel over the flash unit.

Both Rosco and Lee manufacture filters of this type, but there is no common standard; the manufacturers' catalogues provide full details.

Filtration and additional exposure (stops)

Lamp type	Tungsten balanced		Daylight balanced	
US tubes				
Daylight	85B+40M+30Y	+1⅔	50M+50Y	+1⅓
White	60M+50Y	+1⅔	30M+20C	+1
Warm white	50M+40Y	+1	40M+40C	+1
Warm white deluxe	10M+10Y	+⅔	30M+60C	+2
Cool white	60R	+1⅓	40M+10Y	+1
Cool white deluxe	50M+50Y	+1⅓	20M+30C	+⅔
UK tubes				
Lamp	**Tungsten film**		**Daylight film**	
Daylight	85B+30M+10Y	+1⅔	40M+30Y	+1
White	40M+40Y	+1	20C+30M	+1
Warm white	30M+20Y	+1	40C+40M	+1⅓
Warm white deluxe	10Y	+⅓	60C+30M	+1⅔
Cool white	50M+60Y	+1⅓	30M	+⅔
Cool white deluxe	10M+30Y	+⅔	30C+20M	+1
Natural/Colourite	—	—	10R	+⅓
Northlight and artificial daylight	—		85	+⅔
Unidentified	30M	+⅔	50M+50Y	+1⅓

"Impossible" corrections

All cool (i.e. non-incandescent) light sources produce a discontinuous spectrum, as shown below. Some sources, though, are better than others, and electronic flash, for

example, matches daylight perfectly. However, the worst light sources of this type totally lack certain wavelengths, and no amount of filtration will provide a good colour result. The best approach is to light the scene with tungsten or flash, and briefly switch on those light sources that actually appear in the pictures so that they appear illuminated on film. Where this is impossible, use the corrections below—but be prepared for a heavy colour cast.

Filtration and exposure compensation (stops)

Lamp type	Tungsten balanced		Daylight balanced	
High-pressure sodium	50M+20C	+1	80B+20C	+2⅓
Metal halide	60R+20Y	+1⅔	40M+20Y	+1
Deluxe white mercury	70R+10Y	+1⅔	60M+30Y	+1
Clear mercury	90R+40Y	+2	50R+20M+20Y	+1⅓

Colour compensating filters

These filter factors (in stops) are nominal, and they should be checked for critical work.

Units of filtration

Colour	05	10	20	30	40	50
Cyan	⅓	⅓	⅓	⅔	⅔	1
Magenta	⅓	⅓	⅓	⅔	⅔	⅔
Yellow	0	⅓	⅓	⅓	⅓	⅔
Red	⅓	⅓	⅓	⅔	⅔	1
Green	⅓	⅓	⅓	⅔	⅔	1
Blue	⅓	⅓	⅔	⅔	⅔	1⅓

If you have a complete set of the subtractive colours, you can use it to make up additive primaries— 20R=20M+20Y, 20G=20Y+20C, and 20B=20M+20C. However, remember that you should never have filters of all three subtractive colours in use at once, because this simply adds neutral density. Remove equal amounts of all colours until just two filters are in use.

Neutral density filters

The most common application of neutral density filters is in bright light when you want to use wider apertures or slower shutter speed. However, the most widely available filters rarely offer more than about two stops, and a better choice for general purposes is a filter with a density of between 1.8 and 2.0. Kodak manufacture ND gelatin filters with densities from 0.1 to 4.0. B+W glass filters go as far as 4.0 and Tiffen filters to 6.0, but these are considerably more costly than gelatin. Densities of the commoner filters are listed in the filter factor chart on page 98.

Polarizing filters

On a sunny day a polarizing filter intensifies colour and makes the sky reproduce as a deeper shade of blue. It also cuts reflection from nonmetallic surfaces. The effectiveness of a polarizer, though, depends on how you use it.

Making the sky bluer

Light from the sky is not evenly polarized: the area of greatest polarization lies in a band at right-angles to the sun. To find it, extend your arm and point at the sun with your forefinger, with your thumb sticking up. If you turn your wrist, your thumb will point to the band in the sky where the light is most polarized. This band will darken more than the rest of the sky when you fit a polarizing filter and correctly orient it.

Take special care when using a polarizer with ultra-wide-angle lenses, for two reasons. First, the lens takes in such a broad sweep of sky that the uneven polarization is obvious, creating a band of dark blue across a light blue background. Second, the rotating mount of a polarizing filter is thicker than the mount of other filters, increasing the risk of vignetting. If possible, buy oversized filters and use a step-up ring on the lens.

Cutting reflections

Polarizers cut reflections only at certain angles to the reflecting surface. If you are trying to cut reflections from water or a window, position the lens axis of the camera at an angle of about 30–40° from the surface. The effect is more pronounced with telephotos than with wide-angle lenses because a longer focal length lens has a narrower field of view, so rays at the frame corners are reflected from the surface at an angle that closely approximates to the optimum. The optimum angle depends on the refractive index of the reflecting medium:

Tangent of optimum angle = refractive index of reflecting surface

Exposure and viewfinder displays Cameras that incorporate a semi-silvered mirror in the metering systems can produce incorrect exposure with a linear polarizer. Professional-quality cameras that fall into this category include Minolta autofocus models, R-series Leicas, the Pentax LX, Canon F1 and Olympus OM3, 4, 2s and pc. Test other cameras by fitting a polarizer and pointing the camera at an evenly illuminated sheet of matt white paper. Rotating the polarizer should not affect the exposure meter reading. If the reading changes, use a circular polarizer, not a standard linear polarizer.

Viewfinder information displays in certain SLR cameras may disappear when a polarizer is used, but this will not affect exposure metering accuracy.

Adding colour to moving subjects

To colour moving subjects while recording static parts of a
scene in natural hues, you need to make three consecutive
and equal exposures through 25 red, 61 green and 38A blue
filters. Take a meter reading without a filter and open up 1
stop for each exposure. The technique works well with
smoke and water. Use negative film, since colour balance is
unpredictable and you might have to make corrections at
the printing stage.

Filters for monochrome

If you have difficulty remembering the effect of filters on
black and white film, try this mnemonic:

> There are three primary colours, red, green and
> blue. Any one of which holds back the other two.

Actually, of course, the range of filters for black and white
photography is considerably wider than this rhyme sug-
gests, but the principle is correct—a filter of one colour
lightens subjects of the same colour and darkens the
others. These are the most useful filters for general-
purpose monochrome photography.

Filter	No.	Factor 5500	3200K	Effect
Pale Yellow	8	2	1.5	Slight darkening of blue subjects—produces colour response closer to human vision.
Yellow	15	2.5	1.5	Darkens blue skies and shadows moderately. Lightens skin tones and reduces blemishes in portraits.
Orange	21	4	2	Darkens skies considerably—conceals freckles and broken veins in portraits.
Red	25	8	5	Turns blue skies almost black and considerably increases contrast in scenes lit by sun and blue sky.
Deep red	29	20	10	Extreme darkening of sky, empty shadows. Use with underexposure to change sunlight to moonlight.
Yellow-green	11	4	4	Makes haze more prominent; lightens foliage to separate it from blooms

Contrast filters

Filter	No.	Filter factor in Daylight	Tungsten light
Red	23A	6	3
Blue/green	65	16	16
	44	8	8
Blue	47	6	12
	47B	8	16
Violet	34A	8	16
Magenta	33	24	12

Filters for infrared film

Infrared film is sensitive to both visible light and infrared radiation, and for most creative applications you will need to use a filter to remove some of the visible wavelengths. For colour infrared, try a Wratten 12 yellow filter, adding a CC50 cyan if you are using tungsten light. Exposure meters are not sensitive to IR, but, as a starting point for daylight exposures, set an ISO value of 100 and meter without the filter. For more extreme results, use a Wratten 25 or 21.

Black and white infrared film can be used with these filters, but visually opaque Wratten 87, 87C and 88A filters produce a more dramatic effect. These filters look completely black to the eye because they transmit infrared radiation while stopping visible light. Again, meter without the filter, using an E1 of 25 in daylight, or 64 in tungsten light with the 87 filter.

In sheet form, you can use the 87 filter to cover a flash unit for unobtrusive photography using infrared film. All visible light is stopped by the filter and even subjects looking directly at the light source see only a barely perceptible dim red glow.

Also, you can use visually opaque filters with infrared film to cut through haze (but not mist).

Filter tips

- Filters often seem reluctant to part company with a lens, or another of their own species, largely because gripping the mount hard distorts the filter's shape, jamming it in place. The trick is to turn the filter without squeezing it. Try pressing the filter flat against the sole of a shoe and turning the lens.
- If two filters are stuck together, cut two lengths of heavy electrical cable (not flex). Form each into a circle and wrap them round the filters (see opposite). Then you can use the cable to rotate the filters without squeezing them.

Press a stuck filter against the sole of your shoe and turn the lens or use a length of heavy electrical cable.

- If you have to shoot pictures by daylight in a room lit by a plate-glass window, use a 30M filter to cut the green cast created by the glass.
- When using filters in combination, always use as few as possible, and the thinner the better. This is especially important with short focal length lenses— use gels if you have them. With thicker filters, and whenever a filter is used behind the lens, always focus with the filter in place.
- Remember that image distortion attachments, such as starburst "filters", also cut resolution. When absolute sharpness is critical, it is best to shoot the subject without a filter, then add the starbursts with a second exposure. Trace where you want the sparkle on the focusing screen and then replace the subject with a backlit black card. Pierce holes in the card to admit the light sources that create the starbursts.

Filter factors and exposure increase

When using filters in combination, always add density values and compensation in stops, but multiply filter factors together. If you use a TTL meter to determine exposure with deeply coloured filters, resist the temptation to meter with the filter in place—the camera's meter cell may be misled by the coloured light. Instead, meter without the filter and then apply the factor.

If you have a scientific calculator or personal computer, you can easily convert exposure or filter factors to exposure corrections in stops. This is useful for odd values—most photographers know that a filter factor of 16 requires a four-stop increase, but what about a 2.0 neutral density filter that has a factor of 100?

$$\text{Compensation in stops} = \frac{\text{LOG filter factor}}{\text{LOG 2}}$$

Filter factor $= 2^{(\text{compensation in stops})}$

Logarithms are to the base 10. The log of 2 is 0.30103.

Density	Percent transmitted	Filter factor	Exposure increase (stops)
0.1	80	1.25	⅓
0.2	63	1.5	⅔
0.24	57	1.75	¾
0.3	50	2	1
0.35	45	2.25	1¼
0.4	40	2.5	1⅓
0.44	36	2.75	1½
0.5	32	3	1⅔
0.54	28	3.5	1¾
0.6	25	4	2
0.65	22	4.5	2¼
0.7	20	5	2⅓
0.8	16	6	2⅔
0.84	14	7	2¾
0.9	12.5	8	3
0.95	11	9	3¼
1.0	10	10	3⅓
1.07	8	12	3⅔
1.14	7	14	3¾
1.3	5	20	4⅓
1.4	4	25	4⅔
1.48	3	30	5
1.6	2.5	40	5⅓
1.7	2	50	5⅔
1.8	1.5	64	6
1.84	1.4	70	6¼
1.9	1.2	80	6⅓
2.0	1	100	6⅔
2.1	0.8	128	7
2.3	0.5	200	7⅔
2.4	0.4	256	8
2.7	0.2	500	9
3.0	0.1	1000	10
4.0	0.01	10,000	13⅓
6.0	0.00001	1,000,000	20

Bold values mark common ND filters.

Processing

Darkroom disasters

The topic of darkroom techniques and procedures is so broad that it would be impossible to cover even the most common processes here. So what follows is a brief first-aid kit of information, tips and sources of help.

Virtually all colour films are now processed in standard C41 or E6 chemistry. The only common exception is the Kodachrome family, which in most countries can be processed only by Kodak at the specified ISO rating. However, Kodak labs in the UK, USA and Switzerland offer a push/pull service of up to 2 stops. In the USA some independent labs process Kodachrome film. Among the best-known is New York Film Works at 928 Broadway, New York NY 10010. Phone (212) 475-5700. This lab can turn round Kodachrome in 90 minutes, run clip tests, push up to 3 stops and pull 1 stop. Foreign customers can pay by credit card, thus avoiding costly bank dollar drafts.

E4 process films

Kodak Ektachrome Infrared is processed in E4 chemistry—the process superseded by E6. A few laboratories still run E4 process lines, and E4 process kits are available for photographers wishing to process the film themselves.

Laboratories
Argentum 1 Wimpole St W1 London W1M 7AA
Rocky Mountain Film Labs, 145 Madison Street Denver, CO 80206 USA.

Processing kits
Speedibrews Photochemicals, 54 Lovelace Drive, Pyrford Woking, Surrey GU22 8QY.

Identifying unmarked films
Black and white film can be identified by dipping the leader into hot water. Monochrome emulsions soften; colour films do not. The most reliable way to check whether colour films are negative or reversal is to run a clip test—process a short length of film in C−41 chemistry ahead of the rest of the roll. If the film is a negative emulsion, you'll recognize the characteristic yellow mask in the unexposed areas.

Colour casts and underexposure
Underexposed E6 films can be chemically bleached to reduce density, either overall, to correct underexposure, or in just one layer, to put right a colour cast. However, this should be considered a last resort—bracketing and filters are more effective! Retouchers may be able to reduce transparencies in this way.

Colour processed as monochrome

This error will produce a monochrome negative image with a yellow or orange stain. You may be able to make satisfactory prints on panchromatic black and white paper; otherwise, try copying the negative onto panchromatic film. If neither technique is successful, it is possible to remove the stain by mixing a standard film-strength hardening fix bath, and adding 8g/l of citric acid. Treat the negative in wetting agent for one minute, rinse in water for 20 seconds and then immerse the film in the bleach bath for 7–14 minutes, checking constantly to make sure that the image itself is not being bleached. Finally, wash and dry the film.

Kodachrome film is backed with a black anti-halation layer and you can remove this by wiping the film with a 5 percent sodium carbonate solution (keep the emulsion side dry).

Restoring the colours It is usually possible to recover a colour negative image from C–41 or E6 films that have been processed in monochrome chemistry. The procedure for this is as follows:

1 Wash in water for 15 minutes at 23–25°C (73.5–77°F).
2 C–41 process bleach (fresh solution) for 4 minutes at 24–40°C (75–104°F).
3 Wash for 15 minutes at 24–40°C (75–104°F).
4 Reversal exposure to a photolamp at a distance of 30cm (12in)—15 seconds each side of the reel.
5 Develop in C–41 developer for $3\frac{1}{4}$ minutes at 37.8°C ±0.2°C (100.4°F±0.1°F.
6 Continue with the C–41 process.

If the negatives you are starting with appear to be solarized or even positive, add 12g/l of hydroxylamine hydrochloride to the solution at step 5, and increase the process time to 20 minutes.

E6 processed as C–41

Reversal films lack the colour-correcting masking layer of colour negatives and they have considerably higher contrast. Nevertheless, don't write off reversal film erroneously processed in negative chemistry. You may be able to use the negatives to produce acceptable prints. Be warned, though, that blues and greens will be distorted, and you should sandwich the negative in the enlarger with a piece of processed, unexposed C–41 film to reproduce the overall hue of the masking layer. Film that has been underexposed by one stop gives best results—overexposed film may be too contrasty to print. Contrast will in any case be high.

C–41 processed as E6

Kodacolor-type films processed in reversal chemistry present more of a problem. Contrast will be lower than usual and the orange mask distorts hues. However, some correction is possible if the "transparency" is printed onto reversal paper.

Lost leader

If you wind the tail of a half-used film into its 35mm cassette, try to resist the temptation to retrieve it and finish off the roll, since you run the risk of double exposures. However, if you are the only photographer to witness the hijack of the president's plane by an axe-wielding psychopath, this is a risk you may choose to take.

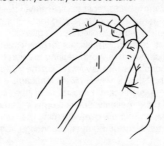

1 Cut a strip of aluminium beer can 34mm (1⅓in) wide and about 100mm (4in) long. Stick a piece of double-sided adhesive tape to the end of the strip. (If you don't have any adhesive tape, try cutting sprocket hole-size hooks in the edge of the aluminium strip.)

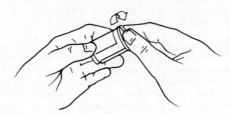

2 Turn the spool clockwise to tighten the film around the core.

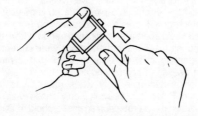

3 Slide the home-made film retriever in through the velvet light trap. Then turn the spool anti-clockwise so that the film unwinds, pressing against the adhesive tape. Pull the metal strip to withdraw the film.

Travel

Country by country guide

The chart on the following pages provides information about nearly 100 of the world's most popular travel destinations, with special reference to photographic requirements. Most of the information was compiled from a questionnaire sent to the tourist boards, embassies or ministries of the countries concerned. It is worth bearing in mind that these "official positions" may not always reflect the true situation.

Language This shows which major language is the first language for a significant proportion of the population: * shows that the majority speak some other language. "Local" shows that for the overwhelming majority, the first language is not a major European language, Chinese or Arabic.

GMT Shows how far the local clocks are set ahead or behind Greenwich Mean Time. Two times separated by a slash shows that the country spans two or more time zones. Where daylight saving is practised, summer time (compared to GMT) is shown in brackets.

Volts & Hertz The commonest voltages and frequency. Bear in mind that electricity supply in remote areas may not be as reliable and stable as it is in western Europe or the USA.

Plug Plug types. Most countries conform to one of three standards—Australian, European or American. However, multiple standards often coexist, as one respondent sardonically observed: "A lot of outlets are designed to accept both US and European 2-pronged plugs (with the result that neither stay in well)". For small appliances (<5A), take a travel adapter, such as the universal type made by Traveller International.

Jabs These are advisable inoculations: C=cholera; Y=yellow fever; T=typhoid; M=malaria; H=Hepatitis; P=Polio. If the letter is in capitals, the jab is mandatory for entry. Brackets indicates that those arriving from infected areas must hold a certificate indicating freedom from the disease. Though these recommendations were current at the time of printing, it is advisable to check with a physician before travelling. Recommendations change, and often inoculation is necessary only when travelling to remote regions. In Brazil, for example, only those visiting the Amazon basin need protection against typhoid, malaria and yellow fever.

TV Shows the television broadcasting standard. A set will only function perfectly if the broadcasting standards in the country of origin exactly match the standards at the destination. If you are using video equipment abroad, it's best to rely on battery power.

IDD Telephone dialling code.

E6 Availability of transparency processing. 4=universal; 3=most urban areas; 2=widely available in the capital; 1=hard to find; 0=non-existent. /K indicates that Kodak has an HQ in the country, though Kodachrome may not be processed locally. Before surrendering film for processing, bear in mind that standards vary widely. The fact that a laboratory runs an E6 line does not guarantee that processing will be consistent and reliable. As a safety measure, consider processing a roll of little value before entrusting dozens to an unknown lab.

C41 Negative processing. For key see E6

Repair Camera repair facilities. Availability is as for E6, and the P/O/N/M/C show whether the major camera manufacturers (Pentax; Olympus; Nikon; Minolta; Canon) have an agency or service centre locally. As a last resort, a watch and clock repairer may be able to fix a purely mechanical camera.

Hire Professional equipment hire facilities. Key as E6. Even if there is a 0 in this column, you may be able to hire underwater cameras at popular diving resorts from the outlets that rent SCUBA apparatus.

Mil Military subjects. F = forbidden to photograph military buildings, troops and bases; P = a permit is needed. Be aware that this bald outline can conceal rules of Kafkaesque complexity. In some countries you can safely photograph a military airbase only from outside the perimeter fence, not from within—but the restriction is relaxed on open days.

Strat Strategic civil structures. Key as above. This category is a generalisation about prohibitions on photographing a wide range of civil structures. The questionnaire itemised border crossings, police stations, oil refineries, dams, post offices, power plants, railway stations, bridges and tunnels individually. Many respondents indicated that the first three of these were forbidden or prohibited. Cautious photographers may wish to avoid these subjects even in countries that nominally permit their photography. If you are crossing a border from country A to country B, read the comments for both nations, and assume that the restrictions apply on both sides of the border.

Notes This column indicates specific prohibited and restricted subjects. However, use common sense: don't assume that you can photograph a subject just because it is not specifically named here. In supposedly free Western nations such as Britain, photographing military installations is legal, but you may be required to spend many hours explaining your interest in the subject.

Sensitivity

At a recent funeral in Surrey, three garishly-dressed mourners turned up. One, an Inuit, took photographs in the church. Another, an African, made a video. The third, a South American Indian, clapped in time to the hymns. When one of the bereaved demanded that they leave, the Inuit offered him a

£20 note. The Eskimo couldn't understand the offence this caused. "After all" he added "when tourists from your country visit our solemn ceremonies, this is how they behave".

Though apocryphal, this story illustrates an important point: it's easy to cause offence if you are unaware of or insensitive to other people's traditions. This is especially true in Islamic nations, where photographing woman can get you into considerable difficulties.

As a general rule anywhere, ask permission before pressing the shutter release. Your pictures may lack spontaneity, but you'll save a lot of aggravation. Remember too that in developing nations scenes that are "picturesque" to foreigners are often shaming symbols of the country's backwardness to local people.

Take special care if you plan to take pictures of people with few clothes on. In Islamic nations even sunbathing in a bikini is not acceptable behaviour, and (with the exception of Russia and the Netherlands) all questionnaire respondents indicated that public nudity is illegal. Significantly, many nations also noted that it wouldn't be a problem in remote spots.

Visas and customs

In earlier editions, this table listed visa requirements for travellers from the UK and commonwealth, and the US. However, the situation has become so complex and subject to revision that useful generalisations are now almost impossible, so check before travelling whether you'll need a visa. In addition you may also need an onward or return ticket and sufficient funds for the trip. Countries that require visas for people who visit on business often admit tourists without one. If you are a professional, you may make it simpler to travel as a tourist.

Many countries have restrictions on the amount of equipment and film you can take in, and some are noted in the chart. For professionals the ceiling is usually either higher or non-existent , but you may need a *carnet* to import your cameras, and Israeli customs even demand a deposit.

Some travel hints are not included in the chart here because they apply to so many destinations.

- Film is often scarce, costly and out of date: never rely on local supplies; always pack more then you need—but check first that there's no limit on how much you take in.
- Don't use the wardrobes of hotels in humid areas—they may contain mothballs or fungicide that could damage film.
- Carry an inventory of equipment; photocopies of receipts sometimes speed you through customs by demonstrating that equipment was not bought locally.
- Theft: few insurance policies cover theft from a parked vehicle. If you're hiring a car, don't get a hatchback, because saloon cars with boots are more secure. Remember that hotel rooms are frequently the target for thieves, and it's best to use locked hard cases, and

padlock them to the plumbing. Always report theft to the police: a list of serial numbers from cameras and lenses may help you recover your property.

- The safest way to fly with equipment is to carry it as cabin luggage. The general rule is just one piece of cabin luggage, total dimensions (length+breadth+height) 114cm. Golf clubs are often exempt from the standard 20 kg maximum free luggage weight, so tripods packed in golf-club cases may travel free.

State	Language	GMT	Volts	Hz	Plug	Jabs	TV	IDD	E6	C-41	Repair	Hire	Mil	Strat	Notes
Algeria	Arab	+1	220/127	50	French	C/Y/t	PAL B	213	1	3	3	1	F	F	Pros need free permit. Always ask before taking pics of people, esp of women
Andorra	Sp/Fr*	+1						376	3	3	2/C	2			
Argentina	Sp	-3	220	50	Eur(US)		PAL N	54	3/K	3	3/ONMCP	3	P		Pros need visa
Australia	Eng	+8/11	240/250	50	Aus	–	PAL B	61	3K	4	3/ONMCP	2	P	P	Photos restricted at aboriginal sites, esp Uluru/Ayers Rock). Daylight saving varies by state
Austria	Ger	+1	220	50	Eur		PAL B/G_.	43	4/K	4	3/ONMCP	3	P		Museums, historic & religious sites, police stations, border posts & oil refineries need permit
Bahamas	Eng	-5	120(240)	60	UK/US	(Y)	NTSC M	1809	1	2					
Barbados	Eng	-4	115(230)	50	UK, US	(Y)	NTSC M	1809	1	1	1	1	P	P	
Belgium	Other/Fr	+1(+2)	220	50	Eur		PAL B/H	32	3/K	1	3/PONMC	3	P		
Bermuda	Eng	-4	120(240)	60	US	–	NTSC M	1809	1	4	1	1			
Brazil	Port	-2/5	127(220)	60	US/Eur	ytm	PAL M	55	3/K	4	3/PONMIC	1	P	P	Violent crime makes security a problem in big cities. Jabs vital only for Amazon region
Brunei	Eng*	+8	220-240	50	UK	(Y)tm	PAL B	673	1	4	1	0	P	P	Pros need permit. No photos in museums or galleries
Bulgaria	Other	+2(3)	220	50	Eur		SECAM D/K	359	3	3	3/M	1	F	F	Apply locally for tourist permit for certain subjects
Canada	Eng/Fr	-2.5/8	120	60	US	–	NTSC M	1	3/K	4	3/PONMIC	3	P		Ask permission before taking pics of native Canadians. Pros may need permit — ask at visa time
Cayman Is	Eng	-5	120	60	US	–		1809	4	4	1				Pros get permit well in advance. All need permit for museums, pub bldgs. No pics in churches. Underwater cameras only for hire
Chile	Sp	-5	220	50	Eur	hpt	NTSC M	56	3/K	3	3/ONCM	2	F	P	Avoid any military subjects. Most historic sites need permit

State	Language	GMT	Volts	Hz	Plug	Jabs	TV	IDD	E6	C-41	Repair	Hire	Mil	Strat	Notes
China	Chi	+8	220			(Y)tm	PAL	86	3	3	3/C	0	F	P	Locally issued permit may be required
Colombia	Sp	-5	110	60	US	C(Y)tm	NTSC M	57	3/K	3	3/OC	1			Permit needed for border posts, police stations, museums
Costa Rica	Sp	-6	120	60	US		NTSC M	506	3	3	1	1			Permit needed for police stations, historic sites, museums
Croatia		+1(2)	220	50	Eur		SECAM	385	3	3	3/OM	1	P		Permit needed in museums, historic sites, Pros may need permit for other subjects
Cuba	Sp	-5(4)	115-120	60	US	t	NTSC M	53	1	3	2	2	P	P	F Photos of some museums, archaeology digs and churches need permit. Apply before departure. No photos near Green Line
Cyprus	Eng*	+2	240	50	UK	–	PAL/SECAM B/G	357	357	1	3	3/MN	3	F	
Czech Republic	Other	+1(2)	220	50	Eur*	–	SECAM D/K	42	3	4	4/PMO	3	F	P	Border crossings and airfields forbidden
Denmark	Other	+1(2)	220	50	Eur	–	PAL B	45	3/K	4	3/PONMC	3	F		Free permit may be required in museums/galleries
Dominican Rep	Sp	-4	110	60	US	–	NTSC M	1809	3	3	2	1			Permit required for pics of borders
Ecuador	Sp	-5	120	60	US	ytm	NTSC M	593	3	4	3	3	F		Contact embassy about import limit on cameras/film. Buy permit on arrival to photograph in some areas/subjects. Airfields forbidden. Jabs needed only in rainforest
Egypt	Arab	+2(3)	220	50	Eur	tm	PAL	20	2/K	4	2/C	2	F	P	Must have permit to shoot in museums, monuments. Cost £E5/day to £E200/hr depending on use. Apply Cairo
El Salvador	Sp	-6	115	60	US	CY	NTSC M	503	3	3	1	1	P		Free permit on arr. for pro military pics
Fiji	Eng*	+12	240	50	Aus	CY	PAL	679	4	4	2/MC	1	F	P	Seek permission from high chief before pics of ceremonies

State	Language	GMT	Volts	Hz	Plug	Jabs	TV	IDD	E6	C-41	Repair	Hire	Mil	Strat	Notes
Finland	Other	+2(3)	220	50	Eur	–	PAL B/G	358	3/K	4	2/PONMC	2	F		English widely spoken. Permit may be needed for some public bldgs. Possible charge. Apply before departure
France	Fr	+1(2)	220	50	Eur/local	–	SECAM L	33	K	4	PONMC	3	F		Photos restricted in signposted military areas
Germany	Ger	+1(2)	220	50	Eur	–	PAL B/G	49	4/K	4	4/PONMC	3	F	F	
Greece	Other	+2(3)	220	50	Local	t	SECAM B/G	30	3/K	4	2/NMC	2	F	F	Permit needed at archaeol. sites, museums. Fee payable for flash, model or tripod
Guadeloupe	Fr	-4	220	50	US	–	SECAM K	590	3	3	0	0			
Guam	Eng*	+10	120	60	US	t	NTSC M	671	3	3	3	3	P		Churches restrict photos
Guatemala	Sp	-6	120	60	US	tm	NTSC M	502	3	3	2	2	P	P	Pros need visa
Haiti	Fr*	-5	230	60	US	(Y)tm	NTSC M	509			0				
Honduras	Sp	-6	110	60	US	(Y)tm	NTSC M	504	1	3	1	1	S		
Hong Kong	Eng/Chi	+8	220	50	UK	–	PAL I	852	4/K	4	4/PONMC	4	P	P	May need permit for museums, religious bldgs
Hungary	Other	+1(2)	220	50	Eur*	–	PAL B/G	36	3	3	3	3			Prohibited subjects signposted
India	Eng*	+5.5	230	50	UK	c(Y)tm	PAL B	91	3	4	3/C	1	F	P	Free permit on arr. for restricted subjects. Religious ceremonies/bathing/women sensitive subjects
Indonesia	Other	+7/9	127(220)	50	Eur	c(Y)tm	PAL B	62	3	4	4/OC	3	F		Buy permit 6 weeks before leaving if taking pictures for publication. Nude photos frowned on
Iran	Other	+3.5/4.5	220	50	Eur	C(Y)tm	SECAM B	98	3	4	3/C	1	F	P	
Iraq	Arab*	+3(4)	220	50	UK/US	(Y)tm	SECAM B	964	2	3	3	3	F	P	Many subjects need permit. If in doubt, ask permission
Ireland	Eng	0	220	50	UK	–	PAL A/I	353	3	4	2/POM	2	P		Police stations require permit. Photos not permitted in museums

State	Language	GMT	Volts	Hz	Plug	Jabs	TV	IDD	E6	C-41	Repair	Hire	Mil	Strat	Notes
Israel	Heb/Arab	+2	220	50	Eur	–	PAL B/G	972	4	4	4/PNMC	3	F		Some religious institutions eg museums forbid photos, esp on saturdays. Refundable deposit required for equipment on entry
Italy	It	+1(+2)	220	50	Eur/local	t	PAL B/G	39	4	4	4/PONMC	3	F	F	May need to buy permit for some subjects. Ask at visa time
Ivory Coast	Fr	0	220	50	French		SECAM K	225							
Jamaica	Eng	-5(4)	110	50	UK/US	–	NTSC M	1809	3	3	2	1			Ask permission before photographing people — esp. market vendors' . Feature films need permit
Japan	Other	+9	100(200)	50/60	US	ct	NTSC M	81	3	4	4/OMCNP	2	P		Photos, flash or tripods may be forbidden, or permit needed at religious and cultural sites
Jordan	Arab	+2	220	50	UK/US/Eur		PAL B/G	962	4	4	2/MC	1	F	P	Photos of bedu, people praying or "backward" subjects may cause offence. Pub. bldgs may need permit
Kenya	Eng*	+3	240	50	UK	cy/m	PAL B	254	3/K	3	3/M	3	F	P	
Korea, South	Other	+9	100/220	60	US	I(C)Y/tm	NTSC M	82	3	4	2/PM	2	F		Restriction of one camera per person. Free permit needed by pros, and to photograph restricted subjects. Apply before departure
Libya	Arab	+1(2)	127(230)	50	Eur	ct	SECAM B	218	1	4	1	0	F	F	Pros need permit. Museums, historic sites need permit
Luxembourg	Fr/Ger*	+1(+2)	220	50		–	PAL, SECAM B	352	4	4	3	1	P		Ask permission for pics of sensitive subjects
Macau	Chi*	+8	220			–	PAL B	853	1	4	2	0	P		Apply before departure for permit to photograph military subjects and interior of some government bldgs
Malaysia	Eng*	+7.5/8	240	50	UK	c(Y)/tm	PAL B	60	3	4	3/PQCNM	3	F	F	No nude pics. Pros buy permit before leaving
Malta	Eng/It*	+1(+2)	240	50		–	PAL B/H	356	3	3	3	1	P		Ask permission in churches and museums. Pros need permit for historic sites

State	Language	GMT	Volts	Hz	Plug	Jabs	TV	IDD	E6	C-41	Repair	Hire	Mil	Strat	Notes
Martinique	Fr*	-4	220	50	2 pin round–		SECAM K	596	3	3	2	2	P		Permit needed for museums, historic sites
Mexico	Sp	-7/8	110	60	US	(Yhm	NTSC M	52	2/K	3	2/ONMC	3	P		Apply for permit 3 months before departure. Some religious, archaeological sites, some Indian tribes forbidden
Monaco	Fr	+1(2)	220	50	Eur		SECAM/PAL	3393	4	4	4	4		P	Pros. need permit from Press Center. Special addit. permission needed for certain subjects
Morocco	Arab/Sp/Fr	0	127/220	50	Eur	tm	SECAM B	212	3	3	3/MC	0	F	F	"Ordinary people do not wish to be photographed" Pro must outline plans at visa time. Amateurs limited to 10 rolls
Nepal	Other	+5h40m	220	50		cytm	PAL B	977	2	2	2	2	P	P	Film import restriction of 15 rolls. Some strategic subjects need permit
Neth Antilles	Dut/Sp/Eng	-4	120-7	50		(Y)	NTSC M	599	2	3	1	0	P	P	Photos restricted or forbidden at power stations, oil refineries
Netherlands	Dut/Eng	+1(2)	220	50	Eur	–	PAL B/G	31	4/K	4	4/PONMC	3	P		No pics at railway stations
New Zealand	Eng	+12(13)	230	50	Aus	–	PAL B	64	3/K	4	3/PONMC	3	P		Pros need to buy permit at visa time
Nicaragua	Sp	-6	120(240)	60	US	tm	NTSC M	505	1	1	1	0	F	P	
Norway	Other	+1(2)	220	50	Eur	–	PAL B/G	47	3/K	4	3/PONMC	3	F		Signs show which strategic structures are forbidden. Photographing older Sami may cause offense
Pakistan	Eng*	+5	230	50	UK	cYtm	PAL B	92	3	3	3/C	0	F	F	Most pro photography needs permit. Tourists limited to one camera. 5 rolls film
Panama	Sp	-5	120	60	US	ytm	NTSC M	507	K	3	MC			F	
Paraguay	Sp	-4(3)	220	50	Eur/local	tm	PAL N	595	3	3	2/C	2	F		

State	Language	GMT	Volts	Hz	Plug	Jabs	TV	IDD	E6	C-41	Repair	Hire	Mil	Strat	Notes
Peru	Sp*	-5	225	60	Eur/US		NTSC M	51	3/K	4	3	1	P		Some public buildings forbidden. Parks, religious, historic sites need permit
Philippines	Eng/Sp*	+8	220	60	US	(Y)hm	NTSC M	63	3/K	4	2/MC	2	P		Pros apply for permit with business visa. Film makers must 'respect the traditions and culture'
Poland	Other	+1(2)	220	50	Eur	–	SECAM D/K	48	3	3	3/NM	0	P		Prohibited subjects indicated with a sign. Some museums, historic sites need permit
Portugal	Port	0(+1)	220	50	Eur	–	PAL B/G	351	4/K	4	3/POMCN	2	P		Pros get permit w/visa for museums/pub bldgs
Puerto Rico	Sp/Eng	-4	120/240	60	Eur	–	NTSC M	1809			C				
Romania	Other	+2	220	50	Eur/Local	–	PAL D/K	40	2	3	1	0	F	P	Tourists restricted to 2 cameras; 24x135 or 10x120 films. Signs show where photos forbidden
Russia	Other	+3/14	220(127)	50	Eur	t	SECAM D/K	7	2	2	2	2	F	F	Pics from air, and many subjects (eg industrial cities) forbidden. Film hard to find/process
San Marino	It	+1(2)	220	50	Eur		PAL	378	4	4	0	0			Permit needed for museums
Senegal	Fr	0	110/220	50	Eur	ytm	SECAM K	221	2	3	2/C	2	P		Religious sites, museums, police station, oil refineries & border crossings need permit
Serbia	Other	+1(2)	220	50	Eur	–	PAL B/H	385	3	3	3	3	F		Avoid police/dams/airfields/power plants
Singapore	Chi/Eng	+8	230	50	UK	(Y)	PAL B	65	4/K	4	1/ONMC	1	F		Permit rarely needed for exterior views — inside strategic subjects, check before shooting
South Africa	Eng*	+2	220	50	Eur	(Y)m	PAL I	27	3	4	3/ONMCP	3	P		Photos of oil refineries need permit
Spain	Sp	+1(2)	220(127)	50	Eur/US	–	PAL B/G	34	3/K	3	3/PONMC	2	P	P	Pros need free permit for certain subjects
Sri Lanka	Eng*	+5.5	230	50	UK	cytm	PAL B	94	0	2	1/C	1	F	P	Permit needed for some historic sites, esp. 'cultural triangle'. Pics of model against religious monuments offensive

State	Language	GMT	Volts	Hz	Plug	Jabs	TV	IDD	E6	C-41	Repair	Hire	Mil	Strat	Notes
Sweden	Other	+1(2)	220/230	50	Eur	–	PAL B/G	46	3/K	3	3/PONMC	3	F		Pros may require permit for some strategic civil structures — check before leaving
Switzerland	Ger/Fr/It	+1(2)	220	50	local	–	PAL B/G	41	3/K	4	3/ONMCP	2	F		May need permit in areas of public buildings not normally open to visitors and in galleries or museums
Syria	Arab*	+2(3)	220(115)	50		(Y)tm	SECAM B	963	3/K	2	C		F		
Taiwan	Chi	+8	110(220)	60	US	C(Y)tm	NTSC M	886	3/K	4	3/ONMCP	3	P	P	Pros may need permit — apply before leaving. Historic sites and museums may require permit
Tanzania	Eng*	+3	230	50	UK	c*(Y)tm	PAL I	255	1	3	1	1	F	F	Pros get permit at visa time
Thailand	Other	+7	220	50	US/Eur	tm	PAL B/M	66	3/K	4	3/OMNCP	2	P	P	Legit pros can get permit for museums, pub. bldgs & strategic structures. Jabs needed only for remote areas
Trinidad	Eng	-4	115/220	60	UK/US	–	NTSC M	1809	1	3	1	1	P		Apply for permit prior to departure
Tunisia	Arab/Fr	+1	220/110	50	Eur	(Y)t	SECAM B/G	216	1	3	0	0	F	F	Pub bldgs forbidden. Pros apply for permit 1 month before trip
Turkey	Other	+3	220	50			PAL B	90	3	4	3/M	3	P	P	Get free permit w/visa for pics in museums and other subjects
UK	Eng	0	240	50	UK	–	PAL I		3/K	4	3/PONMC	2			
Uruguay	Sp	-3	220	50	Eur/Local	tm	PAL N	598	K		NC				
US Virgin Is	Eng/Sp*	-4				t	NTSC M	1809			0				
USA	Eng	-4/11	120	60	USA	–	NTSC M	1	4/K	4	3/PONMC	3			
Venezuela	Sp	-4	120	60	US(Eur)	(Y)tm	NTSC M	58	3/K	4	2/OMC	2	F	F	Pros contact embassy before travelling

X-ray precautions

Crossing international frontiers always involves security checks of some description, and usually these include X-rays. The risk involved when film is X-rayed is a hotly debated issue, as is the value of any precautions: the protection offered by lead bags, for example, is not yet proven. There are few statistics available, but one source has estimated that 0.3 percent of all photographic films processed show some signs of X-ray damage.

Naturally, the best way to make sure that there is no damage to your films is to ask for a hand search of luggage containing film, but this is not always possible. So if you cannot prevent film from being X-rayed, what are the risks?

Photo scientists admit that there is always some effect on film that is X-rayed, but sophisticated testing may be needed to reveal the precise extent. The results of X-rays show up first in the darkest areas of the photographic image after processing, and they take the form of shadows cast by X-ray-absorbing objects that were adjacent to the film at the time of the test. The end caps of 35mm cassettes cast characteristic crescent shapes on the film and zips also leave an immediately recognizable pattern. The marks may appear in colour, since different layers of the film have different sensitivities to X-rays.

Fast film is affected first: though a single pass through an X-ray machine probably won't affect films rated at ISO 400 or slower, faster films should not be X-rayed at all. Tests by Fuji revealed that ISO 1600 colour print film showed damage after just one pass at 0.3 mR (milliroentgens). ISO 400 film needed 10 passes, and ISO 100 film, 30 passes. The Federal Aviation Authority rules set an upper limit of 1 mR for X-ray baggage inspection, so even within the USA the conservative may wish to divide Fuji's figures by 3. Some reports suggest that Soviet Bloc machines use X-ray dosages substantially higher than 1 mR. Speed alone does not determine the susceptibility of film to X-rays—colour films are more sensitive than monochrome and the orientation of the film within the machine significantly affects the damage done. The worst position for film is when the lips of the cassette are directed toward the X-ray beam, so as a last resort try to make sure that film does not go through with the cassettes oriented in this way.

Always ask for a hand search—in the USA at least, Federal Aviation Authority rules (number 108.17) state that everyone is entitled to a hand search if they request one. To make this easier, allow extra check-in time. Pack film cartons in a clear plastic bag to aid inspection and photocopy the facing page to deter airport officials.

The magnetometer arch used to check for metal objects does not harm film—so offer to carry film through the arch if a hand search is refused.

X線厳禁

未現像フィルム在中

DO NOT
X-RAY

Contains Photographic Materials

BITTE NICHT
RÖNTGEN

Inhalt Fotomaterial

NE PAS
PASSER AUX
RAYONS X

Films Photo-sensibles

NO PASEN
POR
RAYOS X

Contiene Material Fotografico

厳禁X光透視

内装照相感光材料

Photography from the air

Large commercial passenger aircraft make far from ideal camera platforms, but you can take steps to make best photographic use of the situation. Fly early or late if you have a choice, because oblique sunlight just after dawn or before dusk picks out ground features and adds much-needed contrast. Check in early so that you can get a window seat with a view that isn't obstructed by the wing. Don't use a polarizing filter—it picks up stress patterns in the plastic windows, which are visible as rainbows. Fit a rubber lens hood that can be pressed against the window to exclude reflections without picking up vibrations from the airframe. Take a lot of pictures on take-off and landing. At cruising altitudes you will see only cloudscapes.

Light aircraft and helicopters

For professional aerial photography, an airliner is no substitute for a light aircraft or helicopter. Fixed-wing craft are cheaper to hire, but helicopters can operate closer to the ground and they usually provide a more unobstructed view. Also, helicopters are more manoeuvrable and they have a far lower airspeed, though static hovering may cause unacceptable vibration (in this respect, turbine-powered craft are more suitable than those with pistons). If you are hiring a light aircraft, pick a single-engined, high-winged plane with windows or doors that you can open or remove in flight.

Your choice of equipment may be dictated by the assignment, but generally a 35mm camera with a near-normal lens is the most convenient outfit. Medium-speed film of around ISO 200 offers a good compromise of the necessary high shutter speed and reasonable image quality. If you normally use reversal film, consider using negatives in order to avoid the need to bracket shots. Infrared film was developed originally for cutting haze out of aerial photographs and, provided lifelike tones and hues are not required, it is often still the best choice.

To reduce the effects of haze, use an 81-series warming filter with colour film, or a 5 or 10 yellow colour compensating filter. Yellow, orange or red filters increase contrast with black and white film.

To set exposure, take readings on the ground and in the air, and split the difference. If it is more than two stops, favour the reading taken on the ground, since haze is probably affecting the aerial reading. Depth of field is irrelevant, so you can choose wide apertures; you can then set faster shutter speeds to reduce the probability of camera shake.

Weather conditions obviously affect the quality of the pictures you take from the air. As a rule of thumb, you need at least ten miles' visibility at ground level for aerial pictures

from any altitude. Optimum conditions are cold weather to reduce thermals, visibility exceeding 24km (15 miles), a clear sky and wind speeds of 16–24km/h (10–15mph) to disperse smoke and mist. Even in good weather, haze is always present. You can minimize the effect of haze by taking pictures when the aircraft lies between the sun and the subject, but unfortunately the frontlighting this produces minimizes shadows—and thus reduces contrast.

Plan the trip carefully, first at home with maps and then with your pilot. Communication may be a problem and a code of hand signals is a practical answer. It should include, as a minimum: "down", "up", "closer", "farther" and "head for home". Remember that the pilot will position the aircraft to give you the best possible view and this may mean that the subject is invisible to the pilot.

Pilots who are used to flying photographic sorties will know how best to position the craft; these tips will help an inexperienced pilot.

Before taking pictures, gently circle the subject to pick the optimum angle. Reduce the throttle to cut airspeed and vibration. Bank the aircraft slightly to make it easier to aim the camera, and slip toward the subject. This technique is unsafe at low altitudes. If you are flying low and the wind is not gusting, ask the pilot instead to reduce the throttle and apply several degrees of flap to slow the plane up.

Processing for colour films should be normal, but develop monochrome film for 10 percent longer to boost contrast for low-level shots. For film exposed over 1.5km (5000ft), increase development by a further 15 percent.

Kites and balloons

As camera platforms kites and balloons provide an inexpensive alternative to aircraft. Kites and balloons lend themselves best to oblique aerial photography from about 100–150m (320–500ft) and verticals at altitudes up to about 600m (2000ft). Unfortunately there is no "best" camera support for all applications, and choice depends largely on wind speed. Spherical balloons are limited to wind speeds below about 16km/h (10mph)—for speeds up to 50km/h (30mph) use a blimp. For wind speeds up to 24km/h (15mph), use a delta kite design; for 24–50km/h (15–30mph) winds, a parafoil design is a better choice, and in higher winds, a box kite is the only practicable option.

The most convenient way to get the camera aloft is usually to build a cradle fixed to a rod tied into the flying line. Fixing a wind-influenced stabilizing surface, such as a vane or drogue, is essential to prevent the camera cradle from rotating around the line. The cradle also needs to incorporate protection for the camera in the event of impact, and some sort of remote control device.

The best introduction to this subject is Mark Cotterell's excellent book *Kite Aerial Photography* (see page 149).

Photo phrase book

English	French	German	Spanish	Italian
General				
Do you mind if I take your photograph?	Permettez-vous que je vous photographie?	Haben Sie etwas dagegen, wenn ich Sie fotografiere?	¿Le puedo sacar una foto?	Vi dispiace se vi faccio una foto?
Would you mind standing over there for a moment?	Est-ce que ça vous ennuierait de vous mettre à un instant?	Würden Sie sich bitte einen Moment da drüben hinstellen?	¿Me hace el favor de ponerse de pie allí un momento?	Vi dispiacerebbe mettervi là in posa per un attimo?
May I take a photograph from over there?	Est-ce qu'il est possible de prendre une photo de là?	Darf ich von dort aus ein Foto machen?	¿Puedo sacar una foto desde allí?	Posso fare una fotografia da là?
Can I bring my car (through here)/ (park here)?	Est-ce que je peux (entrer ici en voiture)/ (stationner ici)?	Kann ich mein Auto (bis hierher bringen)/ (hier abstellen)?	¿Puedo traer mi coche (por aquí)/ (estacionar aquí)?	Posso portare la mia macchina (fino a qui)/ (parcheggiare qui)?
I have much heavy equipment.	J'ai du matériel lourd dans la voiture.	Meine Ausrüstung ist sehr schwer.	Tengo mucho material pesado.	Ho molta attrezzatura pesante.
It will only take five minutes.	Ça ne prendra que cinq minutes.	Das dauert nur fünf Minuten.	Serán sólo cinco minutos.	Ci vorranno solo cinque minuti.
Is there a charge for photography?	Quel est le prix du permis?	Verlangen Sie eine Foto-Gebühr?	¿Se cobra para fotografiar?	Bisogna pagare per fotografare?

Is photography permitted? (with flash)/(with a tripod)?	Est-ce qu'il est permis de prendre des photographies ici? (avec flash)/(avec un pied)?	Darf man hier fotografieren? (mit Blitz)/(mit Stativ)?	¿La fotografía está permitida? (con flash)/(con trípode)?	E' permesso fare fotografie? (con il flash)/(con il treppiede)?
Must I apply for a permit?	Est-ce que je dois obtenir un permis?	Brauche ich eine Genehmigung?	¿Debo solicitar un permiso?	Devo richiedere un permesso?
I do not have time to apply in writing.	Je n'ai pas le temps de soumettre une application écrite.	Die Zeit ist zu knapp, die Genehmigung schriftlich zu beantragen.	No tengo tiempo de solicitar por escrito.	Non ho tempo per fare una richiesta scritta.
I am a professional photographer. It is my job to take photographs.	Je suis un photographe professionnel. C'est mon métier de prendre des photos.	Ich bin Berufsfotograf, das ist meine Arbeit.	Soy fotógrafo profesional. Es mi trabajo sacar fotos.	Sono un fotografo professionista. Fare foto è il mio lavoro.
I am an amateur photographer. These pictures are purely for my own enjoyment.	Je suis un photographe amateur. Ces photos sont uniquement pour mon plaisir personnel.	Fotografieren ist mein Hobby. Diese Aufnahmen sind nur für mich selbst bestimmt.	Soy fotógrafo aficionado. Estas fotos son para uso propio.	Sono un fotografo dilettante. Queste foto sono solamente per il mio piacere personale.
I wish to hire a car with a trunk that can be locked.	Je désire louer une voiture avec un coffre qui ferme à clef.	Ich möchte ein Auto mieten, wo man den Kofferraum abschließen kann.	Quiero alquilar una coche con portaequipajes que cierre con llave.	Vorrei noleggiare una macchina con il baule che può essere chiuso a chiave.

English	French	German	Spanish	Italian
At the camera store/lab				
Where can I (buy)/(process film)/(have a camera repaired) nearby?	Où peut-on (acheter)/(développer des pellicules)/(réparer un appareil-photo) près d'ici?	Wo kann ich hier in der Nähe (Filme kaufen)/(Filme entwickeln lassen)/(eine Kamera repariert bekommen)?	¿Dónde puedo (comprar)/(revelar una película)/(reparar una cámera fotográfica) por aquí cerca?	Dove posso (comprare)/(sviluppare)/(riparare una macchina fotografica) qui vicino?
Please may I have (one)/(five)/(twenty) rolls of (black and white)/(colour reversal)/(negative film).	Je voudrais (une)/(cinq)/(vingt) pellicules/ (noir et blanc)/(diapositive couleur)/(négatif couleur) s'il vous plaît.	Bitte geben Sie mir (eine)/(fünf)/(zwanzig) Rolle(n) (Farbumkehr)/ (Negativfilm).	Por favor, me puede dar (una)/(cinco)/(veinte) película(s) (en blanco y negro)/(inversible en color)/(negativa en color).	Per favore vorrei comprare (una)/(cinque)/(venti) pellicole (in bianco e nero)/(convertibili a colori)/(negativi).
Do you have ISO (64)/(100)/(400)/(1000) film?	Avez-vous du (64)/(100)/(400)/(1000) ISO	Haben Sie DIN (19)/(21)/(24)/(27)/(31) Filme?	¿Usted tiene película de (64)/(100)/(200)/(1000) ISO?	Avete delle pellicole a (64)/(100)/(200)/(400)/(1000) ASA?
Do you have a (polarizing)/(colour conversion)/(colour correction)/(graduated) filter of this diameter?	Avez-vous un filtre (polarisant)/(convertisseur de couleur)/(de correction de couleurs)/(gradué) de ce diamètre?	Haben Sie (Polarisations-)/ (Farbkonversions-)/ (Farbkorrektur/Verlauf-) Filter mit diesem Durchmesser?	¿Usted tiene un filtro (polarizador)/(de conversión del color)/(corrector del color)/ (compensador) de este diámetro?	Avete un filtro (polarizzatore)/(per la conversione dei colori)/(per la correzione dei colori)/(graduato) di questo diametro?

Do you process film?	Est-ce que vous développez?	¿Usted hace revelados?	Entwickeln Sie Filme?	Sviluppate pellicole?
How long does it take?	Ça prend combien de temps?	¿Cuánto tiempo tarda?	Wie lange dauert das?	Quanto tempo ci impiegate?
(One)/(two)/(three)/(four) hours; (overnight)/(one day)/ (one week).	(Une)/(deux)/(trois)/(quatre) heures; (vingt-quatre heures)/ (une journée)/(une semaine).	(Una)/(dos)/(tres)/(cuatro) horas); una noche/(un día)/ (una semana).	(eine)/(zwei)/(drei)/(vier) Stunden)/ (über Nacht)/ (einen Tag)/(eine Woche).	(Una)/(due)/(tre)/(quattro) ore; una notte; (un giorno)/(una settimana).
How much per roll?	Combien par pellicule?	¿Cuánto vale un rollo?	Wieviel macht das pro Film?	Quanto costa per pellicola?
Please (push)/(pull) this by a (third)/ (half)/(one) stop.	Voulez-vous (pousser)/(retenir)/(d'un tiers de cran)/(d'un demi-cran)/(d'un cran) s'il vous plaît.	Por favor (fuerce)/(tire) el revelado (un tercero)/(medio)/(un) paso.	Bitte (verlängern)/(verkürzen) Sie die Entwicklungsdauer um (eine drittel)/(eine halbe)/ (eine) Stufe.	Per favore (spingete)/(tirate) questa pellicola di un (terzo)/(un mezzo)/(uno stop).
Please make a clip test, judge and (run)/(hold) the balance.	Voulez-vous faire un test, juger vous-même et (développer)/(maintenir) la balance.	Por favor, haga una copia de prueba, examínela y (desarróllela)/(mantenga) un balance.	Bitte machen Sie einen Entwicklungstest, beurteilen und (entwickeln Sie den Rest)/ (warten Sie mit dem Rest).	Per favore faccia un provino iniziale, giudichi e (sviluppi)/(aspetti) il resto.
Please (process only)/(process and make a contact sheet)/ (process and mount).	Voulez-vous (seulement développer)/ (développer et faire un contact)/(développer et monter sur caches) s'il vous plaît.	Por favor (revele solamente)/(revele y haga una hoja de contacto)/ (revele y monte).	Bitte (nur entwickeln)/(entwickeln und einen Kontaktabzug herstellen)/(entwickeln und rahmen).	Per favore (sviluppate solamente)/ (sviluppate e fate i provini)/ (Sviluppate e incorniciate).

English	French	German	Spanish	Italian
At the airport				
Please do not X-ray this bag; it contains film.	Ne passez pas ce sac aux rayons-X, s'il vous plaît. Il contient des pellicules.	Bitte durchleuchten Sie diese Tasche nicht. Da sind Filme drin.	No radiografíe este bolso, por favor; contiene película.	Per favore non passate questa borsa ai raggi X, contiene delle pellicole.
Please search this bag by hand.	Examinez ce sac à la main, s'il vous plaît.	Bitte untersuchen Sie diese Tasche mit der Hand.	Registre este bolso a mano, por favor.	Per favore controlli questa borsa a mano.
I purchased all this equipment prior to departure; do you wish to see receipts?	J'ai acheté tout ce matériel avant mon départ; voulez-vous voir les factures d'achat?	Ich habe das alles vor meiner Abreise gekauft; Möchten Sie die Quittungen sehen?	Compré todo este equipo antes de mi salida; ¿quiere ver los recibos?	Ho comprato tutta questa attrezzatura prima della partenza; volete vedere le ricevute?
I wish to fly over this place and take photographs; can anybody here take me?	Je désire survoler cet endroit et prendre des photos; y a-t-il quelqu'un ici pour m'emmener?	Ich möchte hier Luftaufnahmen machen; gibt es hier jemanden, mit dem ich fliegen könnte?	Quiero sobrevolar este lugar y sacar fotos; ¿Hay alguien aquí que pueda llevarme?	Vorrei sorvolare questo luogo e fare della fotografie; c'è qualcuno che mi potrebbe portare?
Please could you take this film as cabin luggage and mail it on arrival?	Pourriez-vous prendre ce paquet de pellicules comme bagage à main et le mettre à la poste en arrivant, s'il vous plaît?	Wären Sie so nett, diesen Film als Handgepäck mitzunehmen und nach Ihrer Ankunft in einen Briefkasten zu werfen?	¿Me hace el favor de llevar esta película como bultos de mano y enviarla por correo cuando llegue?	Per favore potresti portare queste pellicole come bagaglio a mano e spedirle all'arrivo?

At the camera repairers

The shutter (aperture) does not function.	L'obturateur (l'ouverture) ne fonctionne pas.	Der Verschluß (die Blende) funktioniert nicht.	El obturador de plano focal (la abertura) no funciona.	L'otturatore (apertura) non funziona.
I dropped it on this part.	C'est tombé sur ce côté-ci.	Ich habe es auf diesen Teil fallen lassen.	Se me cayó sobre esta pieza.	L'ho fatta cadere qui.
Pictures are consistently (underexposed)/(overexposed).	Les photos sont toujours (sous-exposées)/(surexposées).	Die Bilder sind regelmäßig (unterentwickelt)/(überentwickelt).	Las fotos están constantemente (subexpuestas)/(sobreexpuestas).	Le fotografie sono sempre (sottoesposte)/(sovraesposte).
Pictures are out of focus.	La mise au point n'est pas bonne. Les photos sont floues.	Die Bilder sind nicht scharf.	Las fotos están desenfocadas.	Le fotografie sono sfocate.
The film is fogged.	La pellicule est brouillée.	Der Film ist verschleiert.	La película está velada.	La pellicola è velata.

Parts of the camera

Body	La boîtier	Des Gehäuse	La montura	Il corpo
(Telephoto)/(wide-angle)/(zoom lens)	(Le téléobjectif)/(l'objectif grand angulaire)/(le zoom)	(Ein Teleobjektiv)/(ein Weitwinkel-Objektiv)/(ein Zoom-Objektiv)	(El teleobjetivo)/(objetivo gran angular)/(objetivo de distancia focal variable)	(telefoto)/(grandgolo)/(zoom)
Shutter	L'obturateur	Der Verschluß	El obturador	Otturatore
Shutter release	Le déclencheur	Die Verschlußauslösung	El disparador	Controllo apertura

English	French	German	Spanish	Italian
Parts of the camera continued				
Aperture (control ring/scale)	L'ouverture (la bague du diaphragme)	Die Blende (der Kontrollring/die Skala)	La abertura (el anillo/la escala de control)	Apertura (Anello di controllo/scala)
Focusing ring/scale	Scale (échelle)/l'indicateur de diaphragme	Der Einstellring/die Skala	El anillo de enfoque/la escala de enfoque	Anello messa a fuoco
Motor drive	Le moteur, la motorisation intégrale	Der Motorantrieb	El grupo motorpropulsor	Motore d'avanzamento
Film advance lever	L'avance	Filmtransporthebel	Palanca de adelantar	Leva avanzamento pellicola
Rewind knob	Le bouton de rebobinage	Der Umspulknopf	El botón de rebobinar	Frizione
Viewfinder	Le viseur	Der Motivsucher	El visor	Mirino
Prism	Le prisme	Das Prisma	La prisma	Prisma
Filter	Le filtre	Der Filter	El filtro	Filtro
Focusing screen	La dépoli de mise au point	Die Mattscheibe	La pantalla de enfoque	Schermo della messa a fuoco
Reflex mirror	La visée réflexe	Der Reflexspiegel	El espejo reflex	Lente con specchio reflex

Photography and the law

Making brief generalizations about the laws relating to photography can be a risky business. The laws of each nation differ and, in the USA at least, photographers can fall foul of state law in addition to federal law. However, a few common threads run through the legal practices in most Western nations. As a rule, the laws applying to photography, as to any other area, are based on common sense and precedent, and you can usually avoid most problems by asking yourself a few simple questions.

1 Do I own the picture?

This question becomes a problem only if you ask it **after** pressing the shutter—so ideally, sort the issue out in the contract or commission. As a rule, in both the UK and the USA the photographer owns the negs or transparencies of commissioned work (but see below) unless the photographer is an employee. However, in the USA, and many other places, the person who owns the physical image—the piece of film—may not necessarily be entitled to use the picture for profit. And the owner of the picture may have continuing obligations to the person who commissioned the picture. For example, a wedding photographer may own the negatives, but usually has an obligation to make prints available to the bride and groom.

2 Can I use the picture?

In the UK, copyright law changed in 1989, making photographers the "authors" of photographs, and automatically giving them the copyright—even if the picture was shot to a commission. So unless you have explicitly assigned the copyright to someone else, you can publish the image. However, if the picture is a portrait commissioned for private use, you must respect the sitter's privacy—and this will usually preclude publication without their permission. In the USA, you can publish the picture if you took it on spec (without a commission). But if you were commissioned, and even if you own the film, you may be able to publish the picture only if your contract assigned the copyright to you. In both countries, the copyright in pictures taken by employees remains the property of the employer. Remember too that a contract may be just a verbal understanding.

3 Do I need a model release?

If in doubt, get a model release signed by everyone who is recognizable in the picture. In the USA, you will need a model release if the pictures are to be used for fiction or advertising, but news pictures or those used for educational purposes don't require a model release. A news picture that

is subsequently used for promotional purposes still needs the permission of the subject.

No one model release can ever suit the requirements of every photographer—someone mopping the floor in a cheap restaurant may happily sign a model release that a highly paid fashion model would not even consider. However, in an ideal world, the model should . . .

- Give you the right to use the picture in any way, including distortion, composite form and even in a manner that holds the subject up for ridicule. The more explicitly these conditions are spelled out the greater is your protection—but so too is the subject's reluctance to sign.
- Waive all rights to approve the use of a picture before publication.
- Allow use of their own or a fictitious name.
- Indemnify the photographer, regardless of use—for example, the model release might specifically remove the model's right to sue if the picture was used in such a way as to make him/her look ridiculous.

It is also worth bearing in mind that: though a signature on a model release is desirable (and absolutely necessary for some publications) subjects can give their consent verbally to the use of a picture; payment is not needed to make a model release valid; the model in signing should also make clear that he/she is entitled to sign, and children (under 18 or under 21 in some places) should have parental consent.

4 Can I take a picture?

As a general rule, photography in a public place is unrestricted—you can photograph whoever or whatever you like, wherever you like. The big "but" is that there are other laws that may restrict your actions (see especially the chart on pages 106–112). For example, celebrities are fair game for the news photographer, but a court may regard incessant hounding of a subject as harassment.

Take care in borderline areas: for example, it would be wise to seek legal advice before standing in a public place to take a picture of someone on private property.

5 What if they lose my picture?

Unless you have evidence that you supplied pictures, you will have difficulty obtaining any redress when the pictures are lost, so always make out delivery notes. The more detailed these are the better your case. As minimum, the delivery note should set out the following in the standard terms and conditions:

Terms of use Generally supplying pictures for possible publication does not imply permission to publish. This is granted only after negotiation.

Responsibility The publishers are responsible for the safety of the pictures from the moment they receive them to the moment you get them back.

Duration of loan Specify when you want the pictures back

—and state a charge per picture per week if this time is exceeded.

Loss or damage It is worth stipulating the value of the pictures, though in the worst case your statement of value is likely to be tested in court. A single unrepeatable picture of a celebrity may be worth tens of thousands, but don't expect a court to award the same damages for the loss of 20 similar views of a single sunset. From this, it also follows that the delivery note should record a detailed description of each image supplied.

6 Can they use my picture again?

Repeated use of a picture without further payment is a common complaint, but if it happens you only have yourself to blame. If possible, sell only single-use, non-exclusive rights in a specified territory (e.g. North America, world English-speaking). Read the small print carefully—what seems to be single-use in a home improvements magazine may also cover publication in book form, if the magazine pages are simply bound together unchanged.

7 Can I copy that image?

In a very general sense, copyright law protects original works of all descriptions, and it is best to assume that somebody owns the copyright of every visual image that you see. This even covers TV pictures and the screens of computer programs and video games. If a copyright image appears in your picture, you may be infringing the rights of the copyright owner, but common sense dictates how serious the infringement is. For example, a magazine cover filled with a shot of a TV screen showing a news-worthy event would be infringing copyright, but if the same image appeared incidentally in the background in a fashion picture, the infringement would be more theoretical than real. Copyright lapses after some fixed period that varies from territory to territory. Typically the term is 50 years after the death of the artist—but it can in some circumstances be extended, or it may lapse prematurely.

In the USA, photographic copyright was until recently complicated by the existence of statutory copyright. Until a picture was published, common-law copyright as set out above protected the photographer, but once a picture was published, the photographer no longer enjoyed copyright protection, and had to register the picture at the copyright office to prevent others from using it. Since 1989, even published images have been protected by copyright, but pictures must still be lodged at the Copyright Office if the photographer wishes to take legal action for infringement of copyright. In the US and elsewhere it is not strictly necessary to secure copyright by publishing the word "Copyright" or an abbreviation, or ©, next to the image, together with the year, and the photographer's name. However, many photographers still consider this to be a sensible "belt-and-braces" precaution.

General reference

Finding the sun

Predicting where the sun will be in the sky seems to be a simple task—after all, everyone knows that it rises in the east and sets in the west. Alas, this is only half the truth. The sun in fact rises due east and sets due west only for a short period each year in the temperate latitudes; at other times it traces a different path on its journey from horizon to horizon.

The most valuable information for photographic purposes is the time of sunset and sunrise and the number of hours of daylight. Many daily newspapers print these facts for the here and now, but for other locations around the globe, and for dates in the future, the information is a little more difficult to track down.

At other times, it is useful to know where sunlight will fall during the day. For example, if you are photographing a house and its gardens, this knowledge will allow you to follow the sun around the garden through the day, and perhaps help you to avoid direct, overly harsh sunlight when photographing the interior.

The following charts enable you to find the sun's position, and its rising and setting times, at any location between the Arctic and Antarctic circles on any day of the year. Though the charts look daunting, they are actually not difficult to use, especially if you need only approximate guidance.

Follow these guidelines to the approximate position of the sun. If you require greater precision, you will need to make the corrections listed opposite.

1 Establish your approximate latitude and find the correct chart. It doesn't matter for the time being whether you are north or south of the equator.

2 Read the date table to pick your date line (A–Z) and find that line on the chart.

3 This line represents the sun's path across the sky for the week you have chosen. The horizontal axis represents the horizon, with the points of the compass, N, S, E and W, running across the scale. The elevation (height above the horizon of the sun) is marked on the vertical axis.

4 The curving lines represent hours of the day—morning on the left and afternoon on the right. Where the date line cuts the horizontal axis, you can read off the rising and setting times. These lines do not take into account daylight saving. If daylight saving is in operation, the sun will rise and set one or two hours later than indicated on the chart.

You will notice that all charts have two sets of compass points on the horizontal axis. This is because when the sun is overhead at the equator it appears to be in the south of the sky to everyone in the northern hemisphere, whereas those in the southern hemisphere see the sun in the north.

Between the tropics, the situation is a little more complex, but if you follow the boxed directions you will always be able to find the right scale.

Corrections for greater accuracy

Lack of space and mechanical reproduction mean that these charts are limited in their accuracy to about 5 degrees, or 20 minutes of time. However, complicating factors may reduce this error or increase it, so to be sure of catching the dawn be at your location well before the indicated time on the chart. If you have a particularly precise timetable, or if you just want to know the sun's position with more precision, you will need to take into account all of these corrections.

Your position in the time zone

This is probably the most crucial correction of all. The hour lines on the chart represent the time approximately as it would be indicated by a sundial, so the sun reaches its zenith exactly at noon. However, the world's time system is far more complex than this, and is organized in zones one hour apart. Everyone within each zone sets their clocks to read noon when the sun reaches its zenith at the centre of the zone. However, some time zones are very wide and, in extreme instances, the sun may rise two or three hours later in the west of the time zone than it does in the east.

The easiest way to compensate is to consult an atlas and calculate how many degrees of longitude separate the point at which you are taking pictures from the Greenwich meridian. Divide the number of degrees by 15 to find out how many hours behind or ahead of Greenwich your true local noon is. Compare this with official local time to determine the necessary correction.

For example, suppose you plan to take pictures in Nairobi, Kenya. Nairobi is some 37° east of Greenwich, and dividing this figure by 15 shows that the sun will rise 2.46 hours, or 2 hours and 28 minutes, earlier than at Greenwich. However, the whole of Kenya is in a time zone 3 hours ahead of GMT, so when you reach Nairobi you should set your watch 32 minutes slower than local time when you consult the sun-finder chart.

The horizon

The times shown are most accurate when the sun is observed over the sea. At other places, the horizon is higher and the day is correspondingly shorter.

Compass corrections

If you are using a compass to find north, remember that magnetic north is not the same as true north. The difference may be considerable and it changes year by year. For precision, check a recent map.

Projection distortions

Plotting a hemisphere onto a flat piece of paper inevitably introduces distortions. The projection used here is accurate for the horizon, but common sense shows that, since the points of the compass converge on the zenith, the scale of degrees gets progressively more and more distorted the higher the sun is in the sky. This does not actually introduce an error—it simply means that the charts give the sun's direction with less precision at noon than at dusk and dawn.

Date lines

Closest date	Hemisphere N	S	Closest date	Hemisphere N	S
December 31	A	Z	July 1	Z	A
January 7	B	Y	July 8	Y	B
January 14	C	X	July 15	X	C
January 21	D	W	July 22	W	D
January 28	E	V	July 29	V	E
February 4	F	U	August 5	U	F
February 11	G	T	August 12	T	G
February 18	H	S	August 19	S	H
February 25	I	R	August 26	R	I
March 4	J	Q	September 2	Q	J
March 11	K	P	September 9	P	K
March 18	L	O	September 16	O	L
March 25	M	N	September 23	N	M
April 1	N	M	September 30	M	N
April 8	O	L	October 7	L	O
April 15	P	K	October 14	K	P
April 22	Q	J	October 21	J	Q
April 29	R	I	October 28	I	R
May 6	S	H	November 4	H	S
May 13	T	G	November 11	G	T
May 20	U	F	November 18	F	U
May 27	V	E	November 25	E	V
June 3	W	D	December 2	D	W
June 10	X	C	December 9	C	X
June 17	Y	B	December 16	B	Y
June 24	Z	A	December 23	A	Z

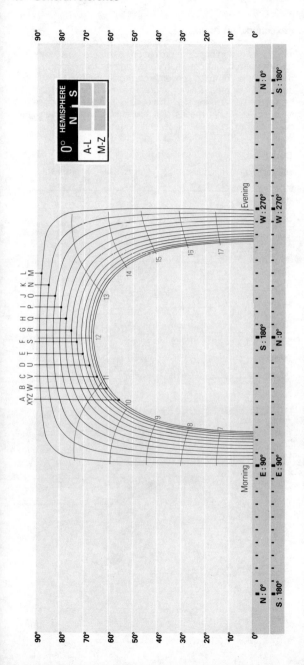

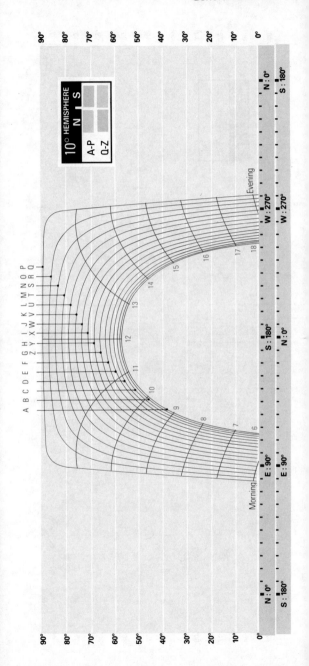

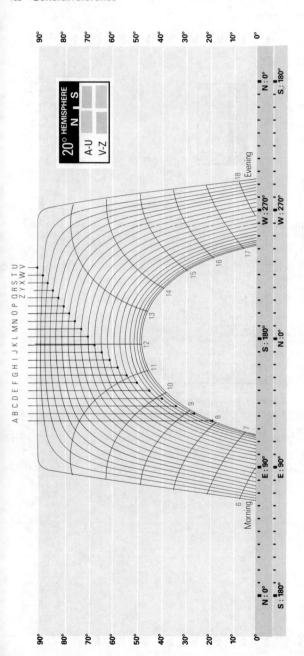

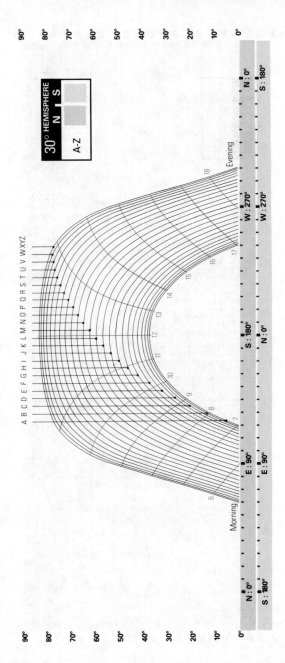

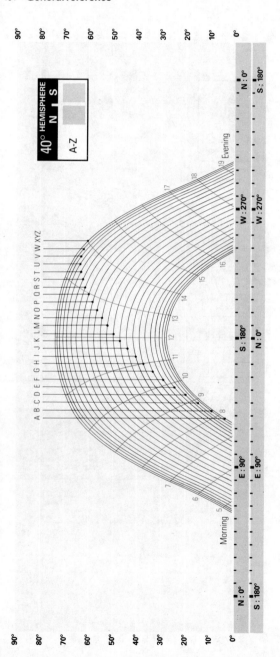

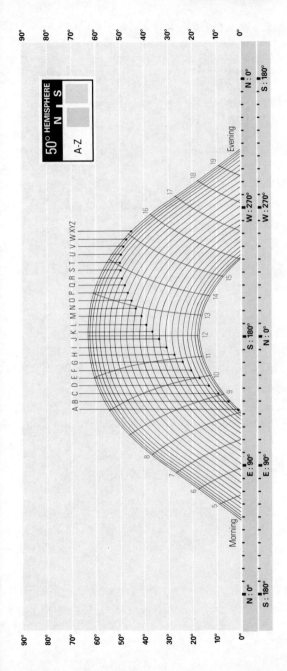

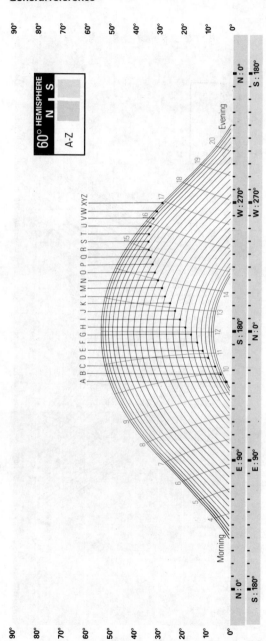

Weather lore and phenomena

Weather forecasts are not tailored to the needs of photographers. To read between the lines, it is necessary to know a little about clouds and about the development of weather systems. The three basic cloud types are heap-shaped (cumulus type), feathery (cirrus type) and layer clouds (stratus type). Of these, the first two create more interesting skies for photographs. Unbroken layer clouds make interesting pictures only at dusk and dawn, when the sun illuminates the underside of stratus-type clouds with red. Most other cloud types are hybrids of these basic forms.

In temperate areas in the northern hemisphere, the dominant weather pattern consists of depressions moving west to east. Predicting the weather is largely a matter of identifying which part of the weather system is overhead now, judging how fast it is moving and deducing what can be expected as the warm and cold fronts advance. This chart plots the development of a typical depression.

Hours	Cloud type	Photographic appeal
−20 to −15	High cirrus low cumulus	Often good conditions for photography, especially if the sky behind is blue.
−15 to −10	Cirrostratus, and possibly low cumulus	High layer clouds create an unattractive, uniformly white sky, often with a halo around the moon or sun.
−12 to −7	Altostratus	Broken cloud—sometimes in the form of a "mackerel sky". Often good on film, especially at dusk and dawn.
−7 to −3	Nimbostratus	Usually solid cloud over whole sky. Poor conditions for photography.
−3 to warm front	Stratocumulus & stratus	Solid cloud cover and boring skies.
Warm sector (duration varies according to how far apart the warm and cold fronts are) stratocumulus and stratus clouds continue.		
Cold front to +3	Nimbostratus	Heavy cloud cover.
+3 to +8	High altostratus & low cumulus	Large, low cumulus clouds provide a textured gray sky that looks dark and threatening on film.
+8 to +12	Cumulonimbus	Spectacular storm clouds and very dramatic skies.
+10 to +20	Cirrus	Serene and attractive wispy clouds often against blue sky.

The crossed winds rule

Wind directions provide a clue to the weather, because the upper and lower winds travel in different directions at different parts of the depression. This is summarized in the crossed winds rule: stand with your back to the surface wind (indicated by throwing grass in the air) and turn 30° clockwise. Now, which way are the high clouds moving?

Left to right—warm front approaching, prospects for photography likely to worsen. Right to left—cold front receding and weather will improve, with better, more varied skies. Clouds approaching or receding—little change.

Notes If you are in the southern hemisphere, face the wind initially. Winds don't obey the rule on the coast, at sea and in the vicinity of geographical features that create their own weather pattern—such as mountains. The rule predicts the weather only a few hours in advance.

Rainbows

Rainbows appear when the sun shines through falling rain. To pinpoint the bow rapidly, stand with your back to the sun, and the bow will be directly in front of you. The centre of a bow is always as far below the horizon as the sun is above —so near the middle of the day the rainbow hops over hedges, while at dusk and dawn it will arc overhead.

There are few hard and fast rules when it comes to photographing the bow: the best technique is probably to move around until the bow is framed against a dark background, such as coniferous trees or dark clouds.

Sky colour and polarization

Increasing latitudes increases the degree of polarization of the light from the sky. This means that the farther north or south you travel from the equator, the more effective a polarizing filter will be at darkening the skies. The zone of maximum polarization makes an arc across the sky at right-angles to the sun, so, for example, when the sun is setting due west, the band of sky running from south to north across the zenith will appear the deepest blue when photographed through a polarizer. If you are using a lens with a focal length of 24mm or shorter, take care with a polarizer, since the deep blue band may be clearly visible.

Lightning

Forked lightning This is easiest to photograph at twilight, since you can then lock the camera on a tripod and leave the shutter open for several seconds to catch several strikes; meter the sky to determine the longest practicable exposure. After twilight the sky will probably appear black, so frame the picture to include foreground lights, or light the foreground separately.

Sheet lightning This is simply forked lightning diffused by cloud and rarely looks as dramatic.

Cells and batteries

Most modern photographic equipment needs batteries, and photographers rely increasingly on other devices that also need portable power. Follow these guidelines to obtain the maximum possible use from a battery or cell.

Choose a single cell or a factory-sealed battery (a battery is a row of cells joined in series or parallel) if possible. Two cells stacked in contact in a battery compartment are less reliable than a single cell with a higher voltage, or a pair of cells with their contacts factory-soldered together.

Pick a cell according to the application: no one type is "best". For details see below, under the different types.

Change light-usage cells regularly: ideally, annually on the same date. Replace them with **new** cells bought from a dealer with a rapid turnover of stock. Don't replace a cell with the standby that has been in the camera bag for a year.

Stock up only with those batteries that are changed often, since few have a shelf life longer than a couple of years. For longer life, store cells at between 10° and 25°C (50° and 77°F), and below 65 percent relative humidity. Dispose of batteries carefully: don't burn them or they will explode.

Mercury cells Mercury cells have a shelf life of approximately 2½ years and they represent an economic choice for equipment that is infrequently used. They may be the only choice for certain types of photographic equipment.

Silver oxide cells Many button cells fall into this category and they are a more costly alternative to mercury cells. However, they have a number of advantages—they provide a slightly higher voltage, better suited to voltage-critical components, such as liquid-crystal displays. Shelf life is comparable with mercury cells. Silver cells have poor low-temperature characteristics, so keep equipment powered by them under warm clothing when temperatures fall below freezing.

Lithium cells There are two types of lithium cell, but most user-exchangeable cells are of the lithium/manganese type. Some photographic equipment can be powered by a single lithium cell instead of a pair of silver or mercury cells, and the single lithium cell may last slightly longer than the pair of silver cells. However, take care because the voltage from a lithium cell tapers off slowly at the end of its life, leading to erratic performance rather than complete failure. The alternatives, by contrast, maintain full power right up to the end.

Zinc-carbon cells The power output of a zinc-carbon cell drops progressively throughout its life—typically, a bulb powered by a zinc-carbon cell will glow yellower as the battery runs down. Consequently, these cells are suitable only for non-critical applications, such as torches.

Manganese alkaline cells Manganese alkaline cells are the "bread and butter" of the photographic world, and with

good reason. They have a long shelf life (up to 3 years) and provide a high power output. They are also very widely available and perform well even at temperatures as low as −20°C (−4°F).

Rechargeable cells

Nickel cadmium batteries (NiCads) appear at first glance to be the ideal way to cut the cost of battery use, especially if you use apparatus that needs many batteries, such as a motor drive. However, bear these points in mind:

NiCad cells These power cells provide a lower voltage than primary cells of comparable size: 1.25V as opposed to 1.5V. In voltage-critical applications, this may be significant.

Primary cells If weight is a factor, and there are no facilities for recharging, long-life primary cells may be better.

Maintenance

NiCad rechargeables are not "maintenance free", though they may be advertised as such. Regular care and maintenance is needed for maximum capacity.

Charging Even when not in use, a NiCad cell or battery loses power constantly and needs "topping up" periodically. Unfortunately, a meter won't tell you when this is necessary, because NiCad cells maintain their full voltage throughout the duty cycle. Voltage then drops rapidly. Only by monitoring usage will you get a true indication of when you need to recharge.

If you totally drain a NiCad cell, recharge it immediately. Failure to do this may cause irreversible damage to the cell. Never overcharge a NiCad—always observe the manufacturer's recommendations, because overcharging can reduce life. Quick-charge cells are—as the name suggests—specially designed for rapid recharging, and regular NiCads cannot be substituted without the risk of overheating and permanent damage.

Memory effect Few photographers take a fully charged cell and totally drain it. Partial use of a cell's capacity eventually inhibits its ability to deliver full power. To prevent this happening, every three months you should totally exhaust the cells by shorting them through a resistance, such as a torch (flashlamp) bulb until the bulb no longer glows, and then recharge them immediately.

Other battery types

Most other types of cell are specifically engineered for use with a particular piece of equipment. Conventional lead-acid accumulators have now been rendered virtually obsolete by "gell-cells", which have a gelled electrolyte. These are perhaps the ideal batteries for flash applications, since they provide rapid recycling, a marginally increased light output and long life, and many have state-of-charge indicators. They are, however, more expensive than most other types.

Conversion Factors

Length

To convert	into	multiply by
inches	centimetres	2.54
inches	metres	0.0254
feet	centimetres	30.48
feet	metres	0.3048
yards	metres	0.9144
miles	kilometres	1.6093
centimetres	inches	0.3937
metres	inches	39.37
metres	feet	3.28
metres	yards	1.0936
kilometres	miles	0.6214
kilometres	yards	1093.664

Area

To convert	into	multiply by
square inches	square cm	6.45
square feet	square m	0.0929
square yards	square m	0.8361
square cm	square in	0.1550
square metres	square feet	10.7584
square metres	square yards	1.1959
acres	hectares	2.471
hectares	acres	0.4047

Weight

To convert	into	multiply by
grains	grams	0.065
grams	grains	15.43
milligrams	grains	0.015
ounces	grams	28.41
grams	ounces	0.0352
lb	kg	0.4535
kg	lb	2.205

Volume

One millilitre (ml) = one cubic centimetre (cc) = 1 litre/1000
One US pint = 16 US fluid ounces
One UK pint = 20 UK fluid ounces
in both systems, 1 quart = 2 pints and 1 gallon = 8 pints

To convert	into	multiply by
US fl oz	ml	29.5625
US pints	l	0.473
US gallons	l	3.784
US fl oz	UK fl oz	0.960
UK fl oz	ml	28.4
UK pints	l	0.568
UK gallons	l	4.544
UK fl oz	US fl oz	1.0409
miles/UK gallon	km/l	0.3526
miles/US gallon	km/l	0.4235

Temperature—the Fahrenheit and Celsius scales

Water boils at 212°F and 100°C
Water freezes at 32°F and 0°C

To convert from Fahrenheit to Celsius
 1 subtract 32
 2 multiply by 5
 3 divide by 9

To convert Celsius to Fahrenheit
 1 multiply by 9
 2 divide by 5
 3 add 32

Common Prefixes

prefix	do this to the following unit
nano	÷ 1000 million
micro	÷ 1 million
milli	÷ 1000
centi	÷ 100
kilo	× 1000
mega	× 1 million

Formulary

Flash powder
Note: *flash powder is explosive. Use it with extreme care.*
Potassium perchlorate 3 parts
Potassium chlorate 3 parts
Magnesium powder 4 parts
Combine the potassium compounds and grind them very
finely, but always keep the magnesium separate until
immediately before exposure. Ignite using a touch paper —
this can be made by soaking paper in a strong potassium
nitrate solution and then allowing it to dry. Mix the powders
extremely carefully. Exposure guidelines for flash powder are
given on page 85.

Hypo test solution
Distilled water 180cc
Potassium permanganate 0.3g
Sodium hydroxide (caustic soda) 0.6g
Water to make 250cc
 To use: pour 1cc of the test solution into a container of
water (250cc for film, 125cc for paper) and then allow wash
water to drain from the prints or negatives into the solution
for 30 seconds. The presence of fix changes the colour to
yellow in about half a minute.

Farmer's reducer
This reducer acts uniformly over the whole tonal range of
the negative or print so it increases contrast. It is a two-part
formula:

Solution A
Water 500cc
Potassium ferricyanide 37.5g

Solution B
Water 2000cc
Sodium thiosulphate crystals (hypo) 480g
For reducing negatives, add 30cc of A to 120cc of B, then
make up to 1 litre with water. For other applications use
stronger solutions. Always mix immediately before use.

Sepia toning
The most widely used process is the sulphide toner, which
has the advantage that it works with virtually all modern
papers. First mix the two solutions:

Bleach
Potassium ferricyanide 30g
Potassium bromide 12g
Sodium carbonate (anhydrous) 15g
Water to make 1 litre

Toner stock solution

Sodium sulphide (anhydrous) 60g

Water to make 150cc

In use, soak dry prints in water, thoroughly wash others, then bleach until the image virtually disappears. Wash prints thoroughly again. The bleach can be reused.

Immediately prior to use, dilute the stock solution with water 20:1, and immerse the print. The toning should be virtually instantaneous—mix fresh solutions if it is not. CAUTION: the toner gives off hydrogen sulphide gas that smells unpleasant, is dangerous in large quantities and damages photographic materials.

Handling Chemicals

The following photographic chemicals are hazardous in their concentrated form:

Acetic acid	C,F	Oxalic acid	H,T
Ammonia	I	p-Methylaminophenol	
Ammonium persulphate	O	sulphate	I
Benzotriazole	H	Phosphoric acid	C
Chloramine-T	H	Potassium chrome alum	I
Diaminophenol		Potassium dichromate	I,O
hydrochloride	I	Potassium oxalate	H
Ethylene glycol	H	Potassium permanganate	O
Ferric chloride	C	Pyrogallol	H
Formaldehyde	I,T	Selenium powder	T
Hydrochloric acid	C,I	Silver nitrate	O
Hydrogen peroxide	C	Sodium carbonate	I
Hydroquinone	H	Sodium dithionate	F
Iodine	H	Sodium hydroxide	C
Methyl alcohol	F,T	Sodium sulphide	C
Methanol	F,T	Sodium thiocyanate	H
Metol	I	Sulphuric acid	I,C

Key

T = toxic; O = oxidizing; F = fire risk; I = irritant; C = corrosive;
H = harmful

Dilution

A	X
	C
B	Y

The criss-cross method of figuring dilution. At A write the dilution of the stock solution; at B the dilution of the diluent (O for water); at C the desired dilution. Subtract C from A and write the result at X. Subtract B from C and write the result at Y. Now mix X parts of A, Y parts of B.

Index

Page numbers in **bold** type refer to main entries

Acknowledgements

With each edition of the book, I have more people to thank, so with a couple of exceptions, there is no longer space to highlight the contribution that each individual made.

Very many thanks to the following: Mike Allen, Brigitte Arora, Adeeb Sha'Ban, Keith Boaz, Sean Casey, David Dewhurst, Luiz F Goltz, Ruth Haertel, Gena Hahn, Gary Hamrick, Lal Hegoda, Richard Hess, Cecil Jospé, Pietro Piero, Mary Platt, C Rajagopal, Christine Samuel, Eric Skopec, James Stephenson, Peter Sutherst, V Toofani, George Wakefield, Otto Zalm.

Sam Booker deserves a special mention. He wrote the computer software that calculated and printed out the sun-finder charts. Members of FIAP—the International Federation of Photographic Arts—also provided valuable on-the-spot information about countries which did not respond to my questionnaire.

Addresses of manufacturers mentioned in the text

Filters
Lee Filters, Central Way, Walworth Industrial Estate, Andover, Hants SP10 5AN, UK.
Tiffen Filters, 90 Oser Avenue, Hauppauge, NY 11788, USA Distributed in the UK by Optex, 20-26 Victoria Road, New Barnet, Hertfordshire EN4 9PF.
Rosco, 36 Bush Avenue, Port Chester, NY 10573, USA 69-71 Upper Ground, London SE1 9PQ, UK.

Bleaches and retouching chemicals
Silverprint, 12B Valetine Place, London SE1 8QH, UK sell small quantities of raw chemicals in the UK. In the USA contact Photographers Formulary, PO Box 5105, Missoula, MT 59806.

Information
The Eastman Kodak Corporation and their subsidiaries world-wide produce many valuable publications about photography, and generously permitted me to draw freely on some of this resource for the data published here. Other useful publications include *A User's Guide to Copyright* by Michael Flint (3rd edition published 1990 by Butterworths) and *The Photographer and the Law* by Don Cassell (published 1989 by BFP). These two books are of UK relevance only. In the USA, the American Society of Magazine Photographers (853 Broadway, NY 10003) is a valuable source of information, though their useful *Professional Business Practices in Photography* was out of print at the time of writing.

Miscellaneous
Traveller International is a source of travel adapters of all descriptions: Volex Accessories Ltd, Leigh Road, Hindley Green, Wigan, Lancashire WN2 4XY.
Porter's Camera Store at PO Box 628, Cedar Falls, Iowa 50613-0628, USA, is a source of many useful and otherwise hard-to-find photo items.

Beattie Intenscreens are distributed in the UK by Morco Ltd., 20 Oak Tree Business Park, Oak Tree Lane, Mansfield NG18 3HQ, England, and in the USA by Beattie systems, 2407 Guthrie Avenue, Cleveland, TN 37311.
 The Kite Store, 48 Neal Street, London WC2H 9PA can supply materials and publications concerning aerial photography from kites, including the book mentioned in the text. What's Up, 4500 Chagrin River Road, Chagrin Falls, Ohio 44022 distribute the book in the USA.

NOTES

NOTES

NOTES